Images of Hope

JOSEPH CARDINAL RATZINGER
(POPE BENEDICT XVI)

Images of Hope

Meditations on Major Feasts

Translated by John Rock
and Graham Harrison

IGNATIUS PRESS SAN FRANCISCO

Title of the German original:
Bilder der Hoffnung
© 1997, 2006 by Verlag Herder, Freiburg im Breisgau

With special acknowledgment to Sister Mary Pius, O.P.,
for her contribution to Father Rock's translation.

Cover art: *Ascension*
Greek icon from the seventeenth century

Cover design by Roxanne Mei Lum

Photograph of the Chair Altar of Saint Peter's in Rome
by Mary Gibson

ISBN 978-0-89870-964-3 (HB)
ISBN 0-89870-964-4 (HB)
Library of Congress Control Number 2006922685
Printed in Canada ∞

Contents

Foreword

In the course of my years in Rome, I was invited again and again by Bavarian Radio to give meditations on the high points of the liturgical year. Frequently, too, I was encouraged to interpret one of the great images that are so abundant in the churches of Rome. At the approach of my seventieth birthday, my brother suggested I collect these texts and see whether they might not produce a small volume that could preserve the interwoven images and thoughts beyond their airing on radio or television and thereby be of help in understanding the Christian feasts. The plan was discussed with Bavarian Radio's advisor on Church matters, Prelate Willibald Leierseder, who had initiated most of the meditations and had selected most of the corresponding images, as well as with Herder publishers. So that is how this small volume originated. It is, certainly, not without a degree of randomness, but it can perhaps help us nevertheless to hear that message of hope again more clearly and to renew that inner gaze which is so often overwhelmed by the flood of images and offers that assail us.

I thank my brother, especially, Cathedral Choir Director Georg Ratzinger, without whose insistent encouragement I would not have taken up this project. I thank also Prelate Leierseder and the people at Bavarian Radio, who assigned the themes and images. I thank Verlag Herder, which exercised great care to ensure that readers might take up this little book with joy.

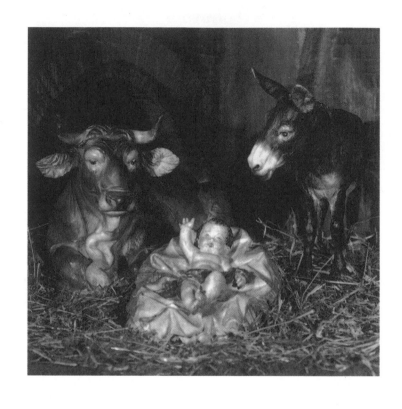

Ox and Ass at the Crib
Detail of the Hadamar Manger, *by Helmut Piccolruaz*

Christmas

Ox and Ass at the Crib

Despite all the hustle and bustle at Christmas, we fervently desire that this festive time will grant us opportunity for reflection, joy, and contact with the goodness of our God and will accordingly renew our resolve to persevere. Before we reflect on what this feast can say to us today, a brief look at the origin of the celebration of Christmas might prove helpful.

The Church's year of feasts first developed, not with a view to the birth of Christ, but from faith in his Resurrection. Thus the original feast of Christianity is Easter, not Christmas. For indeed it was the Resurrection that established Christian faith and let the Church come to be. For this reason, Ignatius of Antioch (who died at the latest in A.D. 117) already called Christians those "who no longer keep the Sabbath but rather live according to the Lord's Day". Being a Christian means living from Easter, that is, from the Resurrection that is celebrated every week on Sunday. It was Hippolytus who first established with certainty, in his commentary on Daniel, written around A.D. 204, that Jesus was born on December 25. Bo Reicke, the early exegete from Basel, pointed moreover to the calendar of feasts, according to which, in Luke's Gospel, the accounts of the birth of the Baptist and the birth of Jesus are related to each other. It

would follow from this that Luke in his Gospel presupposes December 25 as Jesus' day of birth. On that day, the feast of the Dedication of the Temple, introduced by Judas Maccabeus in 164 B.C., was celebrated. At the same time, the date of Jesus' birth was symbolized, so that with him, who arose as God's light in the winter night, the true dedication of the Temple—the arrival of God in the midst of the world—might take place.

Be that as it may, the feast of Christmas did not assume clear contours in Christendom until the fourth century, when it displaced the Roman feast of the unconquered sun-god. Christ's birth became understood as the victory of the true light. Bo Reicke has clearly shown in his notes that an already old Judeo-Christian tradition was contained in this recasting of a pagan celebration into a Christian solemnity.

The special human warmth we feel at Christmas, which has significantly overtaken that of Easter in the hearts of Christians, did not develop until the Middle Ages. It was Francis of Assisi who helped bring this novelty about through his deep love for the man Jesus, for the God with us. As his first biographer, Thomas of Celano, explains in his second description of Francis' life: "He celebrated Christmas more than any other feast with an indescribable joy. He said that this was the feast of feasts, for on this day God became a small child and sucked milk like all children of men. Francis embraced with great affection and devotion the images that represented the child Jesus and stammered words of sympathy as children do words of affection. The name of Jesus was sweet as honey on his lips."

It was such a disposition that gave rise to the famous celebration of Christmas in Greccio. His visits to the Holy Land and to the manger in Saint Mary Major may have inspired him here. What moved him was the longing for nearness, for

reality. He wanted to experience Bethlehem directly. He wanted to experience up close the birth of the child Jesus and to tell all his friends.

Celano recounts the night at the crib in the first biography in a way that never fails to move us and that at the same time has decisively contributed to the development of the most beautiful Christmas custom of the crèche. We can therefore justifiably say that the night at Greccio gave Christendom the festival of Christmas in a brand new way. Accordingly, its own expression, its special warmth and humanity, the humanity of our God, communicated themselves to souls, giving faith a new dimension. The feast of the Resurrection had directed our gaze to God's power, which overcomes death and teaches us to hope for the world to come. Now, however, the defenseless love of God, his humility and goodness, became visible; it sets us apart in this world and wants to instruct us in a new way of living and loving.

Perhaps it might be useful to pause a moment and ask where this Greccio actually is that has attained its own special meaning for the history of faith. It is a small place in the Rieti Valley in Umbria, not very far to the northeast of Rome. Lakes and mountains give this stretch of land its special charm and a quiet beauty that still move us today. Fortunately, the commotion of tourism has hardly affected it. The monastery of Greccio, more than two thousand feet high, has preserved something of the simplicity of its origins. It has remained modest, as has the little village at its feet. The forest surrounds it as it did at the time of the Poverello, inviting us to stop and look. Celano says, moreover, that Francis especially loved the inhabitants of this spot of land because of their poverty and simplicity. He often came here to rest, drawn by a cell of extreme poverty and seclusion in which he could give himself undisturbed to the observation of

heavenly things. Poverty—simplicity—the silence of men and the speech of creation: these were apparently the impressions that bound the Saint of Assisi to this place. So he could be in his Bethlehem and register anew the mystery of Bethlehem in the geography of souls.

But let us return to Christmas of 1223. The land in Greccio was placed at the disposal of the poor man of Assisi by a nobleman named John. According to Celano, John, despite his high lineage and important position, "accorded no particular significance to his noble blood; rather he desired to attain nobility of soul." For this reason Francis loved him.

Celano writes that on that night John received the grace of a wonderful vision. He saw in the manger a small child lying motionless, who was awakened from his sleep through the nearness of Saint Francis. The author adds: "This vision really corresponded to what happened, for the child Jesus really had sunk into the sleep of forgetfulness in many hearts. Through his servant Francis, the remembrance was revived and indelibly engraved in their minds."

This image describes quite accurately the new dimension Francis, with his heart and spirit-filled faith, gave the Christian celebration of Christmas, namely, the discovery of God's revelation in the child Jesus. Precisely in this way, God truly became "Emmanuel", God with us. No barrier of majesty or distance divides us from him. He has drawn so near to us as a child that we unabashedly address him familiarly and can have direct, personal access to the child's heart.

In the child Jesus, the defenselessness of God is apparent. God comes without weapons, because he does not wish to conquer from outside but desires to win and transform us from within. If anything can conquer man's vainglory, his violence, his greed, it is the vulnerability of the child. God assumed this vulnerability in order to conquer us and lead us to himself.

Meanwhile, let us not forget that the highest title of Jesus Christ is "the Son", Son of God. The divine dignity is designated by one word that shows Jesus as the eternal child. His being a child stands in a unique correspondence to his divinity, which is the dignity of the "Son". Thus his being a child gives direction, tells us how we can come to God, how we can come to divinization. It is in this respect that we are to understand his words: "Unless you turn and become like children, you will never enter the kingdom of heaven" (Mt 18:3).

Whoever has not understood the mystery of Christmas has not understood what is decisive in being Christian. Whoever has not accepted this cannot enter into the kingdom of heaven. That is what Francis wanted to remind the Christian world of his own time and every time thereafter.

According to the instructions of Saint Francis, ox and ass were present in the cave of Greccio. He said to the nobleman John: "I wish to evoke remembrance of the child quite realistically, how he was born in Bethlehem, and of all the hardship he must have endured in his childhood. I would like to see with my bodily eyes how it was, to lie in a manger and to sleep on hay between an ox and an ass."

Ever since, ox and ass belong to every crib display. But where do they come from? The Christmas accounts of the New Testament tell nothing of them, as is commonly known. In pursuing this question, we come upon a state of affairs that is important not only for the whole Christmas tradition but also even for the Christmas and Easter piety of the Church in liturgy and popular custom.

Ox and ass are not simply products of a rich fantasy. They have become companions of the Christmas event through the faith of the Church in the unity of Old and New Testaments. Isaiah 1:3 states: "The ox knows its owner, and the ass its

master's crib; but Israel does not know, my people does not understand."

The Church Fathers saw in these words a prophetic saying that points to the new people of God, the Church of Jews and Gentiles. Before God all men, Jews and Gentiles, like oxen and asses, lacked understanding and reason. But the child in the crib opened their eyes, so that they now recognize the voice of the master, the voice of the Lord.

Again and again in medieval depictions of Christmas, both animals are given almost human faces as they stand and bow down knowingly and devotedly before the mystery of the child. That was only logical, for both animals were looked upon as the prophetic cipher concealing the mystery of the Church, our mystery, who are oxen and asses over against the eternal God; oxen and asses whose eyes open that Holy Night so that they can recognize their Lord in the crib.

But do we really recognize him? When we place ox and ass in the crib, we must let the *entire* passage from Isaiah come to mind. It is not only good news—the promise of knowledge to come—but is also judgment on present blindness. Ox and ass know, but "Israel does not know; my people does not understand."

Who are the ox and the ass today, who are "my people", who do not understand? Why is it the case that non-reason knows and reason is blind?

In order to find out, we must return once again with the Church Fathers to the first Christmas. Who did not recognize Jesus? And who did? And why was that so?

Now, the one who did not recognize was Herod, who comprehended nothing as he was told about the child. Rather, he was only more deeply blinded by his lust for power and by the paranoia from which he suffered (Mt 2:3). It was "all Jerusalem with him" that did not recognize (ibid.). It was the men in soft

raiment, the finer society, who did not recognize him (Mt 11:8). It was the learned who did not recognize, the scripture scholars and exegetes, who to be sure knew the right passage but nevertheless comprehended nothing (Mt 2:6).

The ones who understood, in contrast to those just named, were "ox and ass": the shepherds, the Magi, Mary and Joseph. In the stable, where the child Jesus is, you do not find the finer society, for ox and ass are at home there.

What about us? Are we far distant from the stable because we are too fine and sophisticated for it? Do we, too, not get so caught up in scholarly interpretation of the Bible, in establishing the inauthenticity or the genuine historical places, that we become blind to the child himself and perceive nothing of him? Are we not all too often in "Jerusalem", in the palace, inside ourselves, our own vainglory, our fear of persecution, rather than able to hear the angel voices in the night, to go there, and to worship?

So let us look in this night at the faces of the ox and ass asking: My people does not understand; do *you* comprehend the voice of the Lord? When we place the familiar figures in the crib, we should ask God to give our hearts that simplicity which discovers the Lord in the child—as Francis discovered in Greccio. Then what Celano—quite close to the words of Saint Luke concerning the shepherds of the first Holy Night (Lk 2:20)—relates of the participants at Midnight Mass in Greccio could happen to us: Each returned home full of joy.

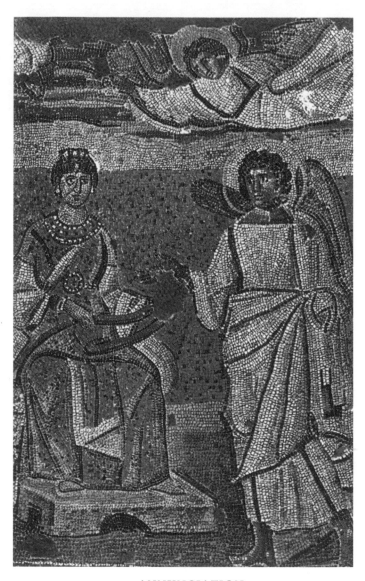

ANNUNCIATION

*Mosaic from the Triumphal Arch
of Saint Mary Major Basilica, Rome*

Christmas

The Message of the Basilica
of Saint Mary Major in Rome

As often as I enter the Basilica of Saint Mary Major, coming
from the noisy streets of Rome, I feel reminded of the invita-
tion of the psalmist: "Be still, and know that I am God" (Ps
46:10). When, not only in summer, droves of tourists hurry
through the church and transform it into a kind of street, an
invitation to be silent, to recollect, and to look emanates from
the mysterious glow of the church that of itself lets the noise
of the everyday seem insignificant. It is as if the centuries of
prayer had remained present in order to accompany us on our
way. The still regions of the soul that otherwise would be
pushed aside by the pressure of cares and routine become free
when we entrust ourselves to the rhythm of this house of
God and its message.

But what is this message? Whoever asks this is well in
danger of drawing away from the special call that seeks to
address him here. One cannot convert what it says into an
easily retrievable dictionary entry. The message requires step-
ping outside the crossfire of questions and answers. It beckons
us instead to stay awhile in order to awaken the powers of the
heart to listen and see. Lingering here leads us beyond being
quick to grasp and then to discard again. So instead of giving

you an answer in formulas and concepts, I invite you to view with me two of this church's pictures and to allow them to tell you what I can only inadequately translate into words.

There is first of all something very remarkable. This church is a Christmas church. As edifice it wants to extend to us the angels' invitation to the shepherds: "For behold, I bring you good news of a great joy which will come to all the people; for to you is born this day in the city of David a Savior, who is Christ the Lord" (Lk 2:10–11). At the same time, however, this house of God seeks to draw us into the shepherds' answer: "Let us go over to Bethlehem and see this thing that has happened, which the Lord has made known to us" (Lk 2:15). Thus one would expect the image of the Holy Night to be the center of this room and its aisles. In fact, this is indeed the case, and it is also not the case.

The mosaics on both the long sides of the nave present, so to speak, all of history as the procession of mankind to the Redeemer. In the middle, above the arch of triumph, to which the aisles lead, where we would expect the birth of Christ to be represented, we find instead only an empty throne and on it a crown, a ruler's mantle, and the cross. On the footstool lies the bundle of history like a pillow bound together with seven red threads. The empty throne, the cross, and history at its feet—that is the Christmas image of this church, which claimed and claims to be the Bethlehem of Rome. Why? If we wish to understand the image we have first to recall that the arch of triumph stands above the crypt that originally was built as the replica of the cave of Bethlehem in which Christ came into the world. Here the relic was and is still venerated that according to tradition is the manger of Bethlehem. So here the procession of history, all the splendor of the mosaics, is abruptly pulled down into the cave, into the stable. The images fall down into reality. The

throne is empty, for the Lord has come down into the stable. The central mosaic, to which everything leads, is likewise only the hand that is extended to us so that we might discover the leap from the images to reality. The rhythm of the space pulls us into a sudden change when it thrusts us out of the brilliant heights of ancient art in the mosaics directly into the depth of the cave, of the stable. It seeks to lead us into the transition from religious aestheticism to the act of faith.

Becoming still in this edifice of the centuries, being deeply moved by the beauty and greatness of its displays, coming into contact full of portent with the great, the wholly other, the eternal, that is the first thing contact with this church gives us. And it is something lofty and noble that we need especially today. But it is not everything. It would remain a beautiful dream, a fleeting feeling without binding authority and, therefore, without power, if we did not let ourselves be taken to the next step, namely, to the Yes of faith. Then something further becomes clear: the cave is not empty. Its actual contents are not the relics that are preserved as the manger of Bethlehem. Its actual content is the Midnight Mass at the birth of Christ. Only there does the transition into reality finally occur. Only there have we reached the Christmas image that is no longer an image. Only when we let ourselves be led there from the message of the room do the words hold true anew: *Today* a Savior is born to you. Yes, really today.

With such thoughts we can now turn to the other image of Saint Mary Major that I would like briefly to present to you, the ancient Marian image that is preserved under the title *Salus populi Romani* in the Borghese Chapel. In order to understand what it says to visitors, to us, we have to recall once again the basic statement of this church. It is a Christmas church, as we said, built as a shell around the stable of Bethlehem, which here for its part is understood as image of

the world and of the Church of God yet, at the same time, demands a surpassing of all images, a superseding of everything merely aesthetic.

Now someone could object that this is not a Christmas church, that is to say, a Christ church, but a Marian church, actually the first Marian church of Rome and of the West. Such an argument would indicate that the questioner had failed to understand the essence of both the Marian devotion of the Church as well as the mystery of Christmas. Christmas has a very particular meaning in the interior structure of Christian faith. We do not celebrate it as we otherwise do the birthdays of great men, because our relationship to Christ is very different from the honor we show great men. What is of interest in them is their work: the thoughts they thought and wrote, the works of art they created, and the mechanisms they left behind. This work belongs to them and is not the work of their mothers, who interest us only insofar as they can shed light on some element of the work.

But Christ counts for us not only through his work, through what he did, but above all through what he was and what he is in the entirety of his person. He counts for us differently from any other man because he is not merely man. He counts because in him earth and heaven touch, and thus in him God for us is tangible as man. The Church Fathers called Mary the holy earth from which he was formed as man. And the miracle is that God in Christ forever remains in union with the earth. Augustine expressed the same thought once as follows: Christ did not want a human father in order to make visible his sonship to God, but he wanted a human mother.

> He wanted to take up the male sex in himself and give distinction to the female sex by honoring his mother. . . . If Christ had appeared as man without regard for the female

sex, women would have to despair of it. However, he honored both, recommended both, assumed both. He is born of the woman. Men, do not despair! Christ saw fit to become a man. Women, do not despair! Christ saw fit to be born of woman. Both sexes work together for salvation. Come the male or come the female, in the faith there is neither man nor woman.

Let us express it a bit differently. In the drama of salvation it is not the case that Mary had a part to play before exiting the stage like an actor who has said his lines and departs. The Incarnation from the woman is not a role that is completed after a short time; rather, it is the abiding being of God with the earth, with men, with us who are earth. That is the reason why Christmas is at the same time both a feast of Mary and a feast of Christ, and for this reason a proper Nativity church must be a Marian church. We should view with the same thoughts the ancient, mysterious image that the Romans call *Salus populi Romani*. According to tradition it is the image that Gregory the Great in 590 carried in a procession through the streets of Rome as the plague tortured the city. At the conclusion of the procession the pestilence ended, and Rome was again healthy. The name of the image means to say to us that man can become healthy again and again from Rome. The maternal goodness of God looks out at us from this at once youthful and time-honored figure, from its knowing and kindly eyes. "As one whom his mother comforts, so I will comfort you", God says to us through the prophet Isaiah (66:13). God apparently prefers to accomplish maternal consolation through the mother, through his mother, and who could be surprised at this? Self-righteousness falls from us before this image. The tenseness of our pride, the fear of feeling, and everything that makes us internally ill dissolve. Depression and despair result when the balance of our

feelings becomes disordered or even suspended. We no longer see the warmth, the consolation, the goodness, and the salutariness in the world, everything that we can perceive only with our hearts. The world becomes despair in the coldness of knowledge that has lost its roots. For this reason, acceptance of this image cures. It gives us back the earth of faith and humanity when we accept its language interiorly and do not close ourselves to it.

The interaction of arch of triumph and cave teaches us to pass from aesthetics to faith, as we said before. The transition to this image can lead us a step farther still. It helps us to loosen faith from the strain of will and intellect and allow it to enter into the whole of our existence. It gives aesthetics back to us in a new and greater way: if we have followed the call of the Savior, we can also receive anew the language of the earth, which he himself assumed. We may open ourselves to the closeness of the mother without fear of falling into false sentimentality or myth. It only becomes mythic or sick when we tear it away from the great context of the mystery of Christ. Then, what has been pushed aside comes back as something esoteric in confused forms whose promise is empty and deceptive. The true consolation appears in the image of the Mother of the Savior. God is near enough for us to touch him, even today. If, in our watchful stay in this church, we become aware of this consolation, then its saving and transforming message has entered into us.

Conversion of the Apostle Paul

The Warrior and the Sufferer

In the nineteenth century, Pope Pius IX erected two powerful statues of the Apostles Peter and Paul at the approach to Saint Peter's Basilica. Both are easily recognizable in their attributes, the keys in the hand of Peter, the sword in the hands of Paul. Anyone without knowledge of Christian history, looking at the imposing figure of the Apostle of the Gentiles, could easily come to the opinion that the statue is that of some great general or warrior who makes history with the sword and subjects whole peoples. That would make him one of many who have attained fame and fortune at the cost of the blood of others. The Christian knows that the sword in the hands of this man has the opposite meaning. It is the tool of his own execution. As a Roman citizen he could not be crucified like Peter. He died by the sword. But even if this was considered a noble execution, Paul belongs in world history to the victims of violence and not to the perpetrators.

Whoever immerses himself in Paul's letters, perhaps in order to find something like a hidden autobiography of the Apostle, will recognize at once that with the attribute of the sword, the tool of the passion, more is being said than something about the last moments in the life of Saint Paul. The sword can rightfully stand as the attribute for his life. "I have

fought the good fight", he says to his favorite pupil, Timothy (2 Tim 4:7), thinking of death and looking back over the path of his life. Such words have led to Paul being described as a warrior, as a man of action, as a man with a fiery nature. A superficial look at his life seems to sustain this appraisal. In four great voyages he traveled a significant part of the then known world and really became a teacher of peoples, a teacher who carried the gospel of Jesus Christ "to the ends of the earth". With his letters he kept the founded communities together, furthered their development, and secured their existence. He passionately opposed his enemies, who were not few in number. He applied all available means to satisfy as effectively as possible the "necessity" of the proclamation that was laid upon him (1 Cor 9:16). And so he is represented again and again as the great activist, as the patron of inventors of new pastoral and missionary strategies.

All that is not false, but it is not the whole Paul. Indeed, whoever sees him only in that way misses the core of his personality. First we must establish that the struggle of Saint Paul was not the struggle of a careerist, of a powerful person, or even of a ruler and conqueror. It was a struggle in the way that Teresa of Avila describes it. She clarifies her saying "God wants and loves spirited souls" with the following sentence: "The first thing the Lord accomplishes for his friends when they become weak consists in giving them courage and taking away the fear of suffering." In this regard, I recall a certainly biased and also, no doubt, slightly unjust comment of Theodore Haecker, which he recorded during the war in his day and night diaries. It can in any case help us to understand what is at stake here. The sentence I mean reads: "Sometimes it seems to me that they have quite forgotten in the Vatican that Peter was not only Bishop of Rome . . . but also a martyr." The struggle of Saint Paul was the struggle of the martyr

from the beginning on. To put it more precisely: at the beginning of his way he belonged to the persecutors and engaged in violence against Christians. From the moment of his conversion, he went over to the crucified Christ and chose for himself the way of Jesus Christ. He was not a diplomat. When he made diplomatic attempts, he had little success. He was a man who had no other weapon than the message of Jesus Christ, to which he dedicated his own life. Already in his Letter to the Philippians (2:17) he says that his life is being poured out like a libation. At the twilight of his life in his last words to Timothy (4:6) this formulation recurs. Paul was a man who was ready to let himself be wounded, and that was his real strength. He did not spare himself and certainly did not try to fashion a fine life for himself by avoiding controversy and unpleasantness.

The opposite is the case. Precisely, the fact that he presented himself, did not spare himself, yielded to the blows and let himself be consumed for the gospel made him trustworthy and built up the Church: "I will most gladly spend and be spent for your souls." This passage from the Second Letter to the Corinthians (12:15) lays bare the innermost essence of this man. Paul was not of the opinion that the chief pastoral task was to avoid controversy. Nor did he think that an apostle should have above all a good press. No, he wanted to arouse, to awaken consciences, even if it cost him his life. From his letters we know that he was anything but a great orator. He shared this lack of rhetorical talent with Moses and with Jeremiah, who had both argued against God that they were completely unsuited for the proposed mission because of deficient speaking ability. "His bodily presence is weak, and his speech of no account" (2 Cor 10:10), his opponents said of him. He said himself about the beginning of his mission in Galatia: "You know it was because of a bodily ailment that I

preached the gospel to you at first" (Gal 4:13). Paul was effective, not because of brilliant rhetoric and sophisticated strategies, but rather because he exerted himself and left himself vulnerable in service of the gospel. The Church even today can convince people only insofar as her ambassadors are ready to let themselves be wounded. Where the readiness to suffer is lacking, so too is the essential evidence of truth on which the Church depends. Her struggle can only ever be the struggle of those who let themselves be poured out: the struggle of martyrs.

To be sure, we can attribute still another meaning to the sword in the hands of Saint Paul than that of the martyr's tool. In Scripture the sword is also the symbol for the Word of God, which is "living and active, sharper than any two-edged sword . . . and discerning the thoughts and intentions of the heart" (Heb 4:12). Paul wielded this sword, and with it he conquered men. Ultimately, "sword" is simply an image for the power of truth, which is of a wholly unique nature. Truth can hurt; it can wound—that is its nature as sword. Because life often appears more comfortable lived in the lie or simply without regard to truth than according to the demands of truth, men get angry about the truth. They want to suppress it, repress it, evade it. Which of us could deny that truth has not sometimes been disturbing—the truth about oneself, the truth about what we should do and let go of? Which of us can maintain that he has never tried to steal past the truth or tried at least to fashion it so that it becomes less painful? Paul was uncomfortable because he was a man of truth. Whoever commits himself entirely to the truth, has no other weapon but truth, desires no other task than truth, may not necessarily be killed, but he will always approach the vicinity of martyrdom. He will become a sufferer. To proclaim truth without becoming a fanatic or a dogmatist—that would be the great task.

Paul may at times become a little acerbic in a dispute and come close to fanaticism. But he was by no means a fanatic. Texts full of kindliness, as we see in all his letters but most beautifully perhaps in the Letter to the Philippians, are the real marks of his character. He was able to remain free of fanaticism because he did not speak for himself; rather, he bore the gift of another to men, namely, truth from Christ, who died for truth and remained loving unto death. Even there, I believe, we must correct our picture of Paul a little. We have too much in our ear the pugnacious texts of Paul. Something similar to what is true for Moses is applicable here as well. We see Moses as "horned", the iron man, the outraged. But the Book of Numbers says of him: Moses was the mildest of men (12:3; LXX). Whoever reads Paul entirely will discover the mild Paul. We said before that his success is connected to his readiness to suffer. Now we must add the following: suffering and truth belong together. Paul was resisted because he was a man of truth. His words and life still have meaning today because he served truth and suffered on its behalf. Suffering is the necessary authentication of truth, but only truth gives meaning to suffering.

The figures of the two Apostles Peter and Paul stand at the approach to Saint Peter's Basilica. The two are also associated with each other on the main portal of Saint Paul Outside the Walls, where scenes of their lives and sufferings are depicted. From the beginning on, the Christian tradition has considered Peter and Paul inseparable from one another. Together they represent the whole gospel. In Rome, the association of the two brothers in the faith has acquired another quite specific meaning. Christians of Rome saw them as alternatives to the mythical pair of brothers who, according to legend, founded the city of Rome: Romulus and Remus. These two men stand in remarkable correspondence to the first pair of

brothers of the biblical narrative, Cain and Abel. One becomes the murderer of the other. Humanly speaking, the word brotherliness leaves a bitter taste. How it can be seen among men is depicted across all religions in such pairs of brothers. Peter and Paul, who were in human terms so different from one other and, truthfully, not without conflicts, appear as the founders of a new city, as the embodiment of the new and true way of brotherliness that has become possible through the gospel of Jesus Christ. The world is saved, not by the sword of the conquerors, but by the sword of those who suffer. Only following Christ leads to the new brotherliness, to the new city. This is what the pair of brothers says to us through the two great basilicas of Rome.

"Primacy in Love"

The Chair Altar of Saint Peter's in Rome

Anyone who, after wandering through the massive nave of
Saint Peter's Basilica, at last arrives at the final altar in the apse
would probably expect here a triumphal depiction of Saint
Peter, around whose tomb the church is built. But nothing of
the kind is the case. The figure of the Apostle does not appear
among the sculptures of this altar. Instead, we stand before an
empty throne that almost seems to float but is supported by
the four figures of the great Church teachers of the West and
the East. The muted light over the throne emanates from the
window surrounded by floating angels, who conduct the rays
of light downward.

What is this whole composition trying to express? What
does it tell us? It seems to me that a deep analysis of the
essence of the Church lies hidden here, is contained here, an
analysis of the office of Peter. Let us begin with the window,
with its muted colors, which both gathers in to the center and
opens outward and upward. It unites the Church with cre-
ation as a whole. It signifies through the dove of the Holy
Spirit that God is the actual source of all light. But it tells us
also something else: the Church herself is in essence, so to

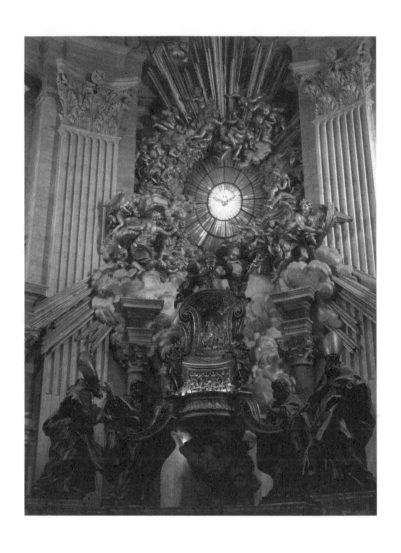

The Chair of Saint Peter

speak, a window, a place of contact between the other-worldly mystery of God and our world, the place where the world is permeable to the radiance of his light. The Church is not there for herself; she is not an end, but rather a point of departure beyond herself and us. The more transparent she becomes for the other, from whom she comes and to whom she leads, the more she fulfills her true essence. Through the window of her faith God enters this world and awakens in us the longing for what is greater. The Church is the place of encounter where God meets us and we find God. It is her task to open up a world closing in on itself, to give it the light without which it would be unlivable.

Let us look now at the next level of the altar: the empty cathedra made of gilded bronze, in which a wooden chair from the ninth century is embedded, held for a long time to be the cathedra of the Apostle Peter and for this reason placed in this location. The meaning of this part of the altar is thereby made clear. The teaching chair of Peter says more than a picture could say. It expresses the abiding presence of the Apostle, who as teacher remains present in his successors. The chair of the Apostle is a sign of nobility—it is the throne of truth, which in that hour at Caesarea became his and his successors' charge. The seat of the one who teaches reechoes, so to speak, for our memory the word of the Lord from the room of the Last Supper: "I have prayed for you that your faith may not fail; and when you have turned again, strengthen your brethren" (Lk 22:32). But there is also another remembrance connected to the chair of the Apostle: the saying of Ignatius of Antioch, who in the year 110 in his Letter to the Romans called the Church of Rome "the primacy of love". Primacy in faith must be primacy in love. The two are not to be separated from each other. A faith without love would no longer be the faith of Jesus Christ. The idea of

Saint Ignatius was however still more concrete: the word "love" is in the language of the early Church also an expression for the Eucharist. Eucharist originates in the love of Jesus Christ, who gave his life for us. In the Eucharist, he evermore shares himself with us; he places himself in our hands. Through the Eucharist he fulfills evermore his promise that from the Cross he will draw us into his open arms (see Jn 12:32). In Christ's embrace we are led to one another. We are taken into the one Christ, and thereby we now also belong reciprocally together. I can no longer consider anyone a stranger who stands in the same contact with Christ.

These are all, however, in no way remote mystical thoughts. Eucharist is the basic form of the Church. The Church is formed in the eucharistic assembly. And since all assemblies of all places and all times always belong only to the one Christ, it follows that they all form only one single Church. They lay, so to speak, a net of brotherhood across the world and join the near and the far to one another so that through Christ they are all near. Now we usually tend to think that love and order are opposites. Where there is love, order is no longer needed because all has become self-evident. But that is a misunderstanding of love as well as of order. True human order is something different from the bars one places before beasts of prey so that they are restrained. Order is respect for the other and for one's own, which is then most loved when it is taken in its correct sense. Thus order belongs to the Eucharist, and its order is the actual core of the order of the Church. The empty chair that points to the primacy in love speaks to us accordingly of the harmony between love and order. It points in its deepest aspect to Christ as the true primate, the true presider in love. It points to the fact that the Church has her center in the liturgy. It tells us that the Church can remain one only from communion

with the crucified Christ. No organizational efficiency can guarantee her unity. She can be and remain world Church only when her unity is more than that of an organization—when she lives from Christ. Only the eucharistic faith, only the assembly around the present Lord can she keep for the long term. And from here she receives her order. The Church is not ruled by majority decisions but rather through the faith that matures in the encounter with Christ in the liturgy.

The Petrine service is primacy in love, which means care for the fact that the Church takes her measure from the Eucharist. She becomes all the more united, the more she lives from the eucharistic dimension and the more she remains true in the Eucharist to the dimension of the tradition of faith. Love will also mature from unity, love that is directed to the world. The Eucharist is based on the act of love of Jesus Christ unto death. That means, too, that anyone who views pain as something that should be abolished or at least left to others is someone incapable of love. "Primacy in love": we spoke in the beginning about the empty throne, but now it is apparent that the "throne" of the Eucharist is not a throne of lordship but rather the hard chair of the one who serves.

Let us now look at the third level of the altar, at the Fathers who bear the throne of serving. The two teachers of the East, Chrysostom and Athanasius, embody together with the Latin Fathers Ambrose and Augustine the entirety of the tradition and thus the fullness of the faith of the one Church. Two considerations are important here: love stands on faith. It collapses when man lacks orientation. It falls apart when man can no longer perceive God. Like and with love, order and justice also stand on faith; authority in the Church stands on faith. The Church cannot conceive for herself how she wants to be ordered. She can only try ever more clearly to understand the inner call of faith and to live from faith. She does

not need the majority principle, which always has something atrocious about it: the subordinated part must bend to the decision of the majority for the sake of peace even when this decision is perhaps misguided or even destructive. In human arrangements, there is perhaps no alternative. But in the Church the binding to faith protects all of us: each is bound to faith, and in this respect the sacramental order guarantees more freedom than could be given by those who would subject the Church to the majority principle.

A second consideration is needed here: the Church Fathers appear as the guarantors of loyalty to Sacred Scripture. The hypotheses of human interpretation waver. They cannot carry the throne. The life-sustaining power of the scriptural word is interpreted and applied in the faith that the Fathers and the great councils have learned from that word. The one who holds to this has found what gives secure ground in times of change.

Finally, now, we must not forget the whole for the parts. For the three levels of the altar take us into a movement that is ascent and descent at the same time. Faith leads to love. Here it becomes evident whether it is faith at all. A dark, complaining, egotistic faith is false faith. Whoever discovers Christ, whoever discovers the worldwide net of love that he has cast in the Eucharist, must be joyful and must become a giver himself. Faith leads to love, and only through love do we attain to the heights of the window, to the view to the living God, to contact with the streaming light of the Holy Spirit. Thus the two directions permeate each other. The light comes from God, flows downward awakening faith and love, in order then to take us up the ladder that leads from faith to love and to the light of the eternal.

The inner dynamic into which the altar draws us allows finally a last element to become understandable. The window

of the Holy Spirit does not stand there on its own. It is surrounded by the overflowing fullness of angels, by a choir of joy. That is to say, God is never alone. That would contradict his essence. Love is participation, community, joy. This perception allows still another thought to emerge. Sound joins the light. We think we hear them singing, these angels, for we cannot imagine these streams of joy to be silent or as talking idly or shouting. They can be perceived only as praise in which harmony and diversity unite. "Yet you are . . . enthroned on the praises of Israel", we read in the psalm (22:3). Praise is likewise the cloud of joy through which God comes and which bears him as its companion into this world. Liturgy is therefore the eternal light shining into our world. It is God's joy, sounding into our world. And it is at the same time our feeling about the consoling glow of this light out of the depth of our questions and confusion, climbing up the ladder that leads from faith to love, thereby opening the view to hope.

Easter

"I Do Indeed Hear the Message . . ."

The Easter poem of Reiner Kunze from the year 1984 expresses quite accurately the impressions of our time vis-à-vis the Easter proclamation.

The bells rang,
As if they were clanging for joy
over the empty grave

Over that which once
so consoled,

and that has sustained astonishment for 2000 years

However even though the bells
hammered so forcefully against the midnight—
nothing in the darkness changed.

In considering these words I realized that Goethe's Faust said the same thing in a different language. In the moment of despair over the poverty of the human condition, over the impossibility of coming near to the divine, he wants to put an end to his life. The contradiction of human existence becomes unbearable for him. There is the longing for the infinite, the highest, that cannot be dismissed. It goes together

with the impossibility of breaking out of the limits of our knowledge, of seeing what actually is, of seeing whether there is a purpose for our existence. The same Faust will later experience that his assistant Wagner succeeded in producing a man *in vitro*. But this expansion of human power cannot vitiate the despair over the darkness of our existence; rather, it only augments it. For blind power is even more terrible and above all more dangerous than blindness in powerlessness. This Faust stands for modern man, who at first experiences himself at the dawn of the new age as having the same rank as God and believes he can take creation in hand in a new and better way, only then to fall into the despair of one who is in fact only a worm who writhes in the dust. The abolition of man seems thus to be the best solution, and Faust takes it symbolically in hand by seeking the drunken stupor of the deadly draft. If he cannot beat death, then he wants at least to cause his own death.

At this moment, when the despairing Faust sets about redemption through causing his own death, the Easter bells ring. The proclamation sounds: Christ is risen. When this announcement becomes audible, precisely what Kunze described occurs: joy that there was once something so consoling and that the astonishment has lasted two thousand years. To be sure, Faust is not in a position, either, to believe the proclamation, but would he also say, "Nothing in the darkness was changed"? He does not believe, but remembrance of the astonishment moves his soul. Remembrance of what was once faith brings him back to the courage of existence. Has not something in the darkness indeed been changed? Even after the loss of faith, does not an afterglow remain that has awakened him? Is it not the case that even in doubt and in disbelief the peculiar proclamation of the empty grave leaves behind a mysterious disquiet that we deny because we are

indeed enlightened men and know that such a thing does not happen, but that pursues us nonetheless? Are we not like the disciples who dismissed what they presumed to be women's prattle but who, in the stillness of their manly wisdom, suddenly were no longer so sure? The Fathers depicted the Church as woman, and perhaps John already saw an image of the Church in Mary Magdalen, who was the first to see the Risen One. She comes even today into our quite technical world with the seeing simplicity of her heart and tells it what does not seem to fit at all: Christ is risen. And somehow no one can any longer completely bypass this proclamation. It could well be true . . . Who may rule it out, since the newest science teaches us that, on the one hand, everything is possible and, on the other hand, nothing is really certain and dependable?

What should we do in such a situation, *how* should we celebrate Easter? The doubting [*Zweifel*] of all certainties—nothing any longer can be held to be impossible, nor can anything be held to be definitively certain—does not lead us out of Faust's despair [*Verzweiflung*]. Doubt only does away with the pathos. Certainly, it is worth something when the walls of ossified certainties collapse with which the spirit of the modern age wanted permanently to enclose the world and man. But scepticism is not a foundation for life. "One does not gamble one's own fate away with the dice of a hypothesis", George Bernanos once said, in order to be sure to illuminate the tragedy of a theologian for whom the hypothesis had become the only source of his analysis. How can we approach the Easter faith? How can we bring the message to ourselves or ourselves to the message so that a bit of darkness is dispelled and we learn to live anew? In view of this moving question, a saying of the martyr-bishop Ignatius of Antioch, from his Letter to the Romans, comes to mind;

he writes: "Christianity is not the work of persuasion, but of real power" (3:3). One cannot be persuaded to faith; one also should not be persuaded. But what then? How does one come to the great, to the power of the real itself, to which Ignatius points?

The answer of the ancient Church was that one has to be on the way, one has to take the word as way. One must immerse oneself in it in order through the experiment of life to come to the experience of reality. For this reason the catechumenate was created. That means that faith was not proclaimed as something purely intellectual, as mere information, but rather was tested and acquired gradually in a process of familiarization and practice. That is also quite logical. Every insight demands its own method. The way must be adjusted to the particular kind of knowing person. I cannot simply philosophize theoretically about medicine. If medicine is to become the art of knowing and of being able to know, it demands real interaction with the patient and with the illness. And even that demands again more than the ability to use instruments and to read off amounts. It demands regard for this man, in whom it is not just a chemical process that has been disturbed, which I can control and rectify with other chemical procedures. The man himself suffers. In the chemical procedure, his whole humanity is involved. If I leave out the living person, then I have excluded the real subject of the event. It becomes clear in this example that a way of thinking that wants to take things in hand, to analyze and control them, does not lead to the goal. Some things are discerned, not through domination, but only through service, and these are the higher ways of perception. For what we are able to dominate is beneath us. A thinking that persists in dissecting and putting together is in its essence materialistic and reaches only to a certain threshold. So beyond dissecting

and analyzing, the physician needs dedication to the person in whom the characteristics of the sickness appear.

Our example has unexpectedly brought us directly to the subject itself, for faith in the Resurrection is concerned with the sickness that afflicts us. It is concerned with the inner wounding of our existence by death and with the hidden God who encounters us in death and there lets himself be recognized. We are on a dead-end street if we think that the Easter proclamation is exclusively about a historical-critical problem of an alleged fact of long ago. One could leave that issue to historians, who can establish whether it is believable or not. But how do they want to determine this? They are as unequal to the task as we all are. They cannot recall it, any more than we can, and they have no other sources at their disposal than those that are available to us all. The determination of this or that discrepancy between the different reports is not sufficient for a judgment. The fact that a series of testimonies independent of each other substantially agree is much more important. But the distance of two thousand years naturally cannot reconcile them. Then the modern world-view usually must help out; this supposedly tells us that there could not really have been a resurrection because we do not know of such a type of dematerialization or of the lightning-like transformation of matter. So we leave the body in the grave. What then remains are a couple of more or less subjective visions. Decay has the last word, and the Resurrection has withdrawn into idealistic talk. In truth the method here simply expects too much, and the approach is wrong. Whoever reduces the Easter proclamation to the fact of a past event has already passed it by. For how could one want to build an entire life, present and future, on a moment lost in the past and now far removed from us?

What the Easter proclamation tells us reaches into a depth

we cannot attain with a few intellectual tools. What is stimu-
lating and new, however, is that God, as the Beirut theologian
Jean Corbon puts it, does not preach the gospel down to us
from above; but rather, he tells it to us by drinking the chalice
of death. Then, however, we cannot hear him from above
down but must encounter him as he encounters us, with the
entire realism of an existence held captive by death. Let us
hear Jean Corbon again: "If God's arrival in man did not
reach all the way to death, he was mocking man. And that is
the case in all religions and ideologies: Since they cannot
drive out death, they distract man from it." The "folly of
mystery" of which Saint Paul speaks (1 Cor 1:17–25) "lies in
the opposite, namely, in entering into death". In addition,
there is something else that Corbon has also indicated. All
empirical events are transient. They are bound to a particular
time period of unwinding history and then are over, even if
each of them leaves behind a more or less deep trace in the
figure of history. But that death is dead is an event that breaks
out of the course of death and becoming. It is a hole in the
wall of transitoriness that now stands open. It does not simply
sink into the past. It to be sure once occurred, but, as the
Letter to the Hebrews says, this once is a once and for all, and
it opens to an always. So it is since then. What has happened
remains, and we must seek access to this present, to this
always, so that we can recognize the once—not the other way
around.

How does one arrive at this present of the past, at this
always of the once and for all, at the today of Easter? As a first
ground rule we can say: on this path we need witnesses. That
was so from the beginning; it belongs to the structure of
this insight. The Risen One does not show himself in a great
public spectacle before the masses. That is certainly not the
way of perception that could come closer to him. He shows

himself to witnesses who accompanied him on a part of his path to death. In accompanying them, one can encounter the truth. This path has various stages and ways. I would like to recall as an example a path to conversion in our time, namely, that of Tatjana Goritcheva. She had learned that the goal of life is to excel, "to be cleverer than the others, more capable, stronger. . . . Never, however, did anyone say to me that the highest thing in life does not lie in surpassing and defeating others but rather in loving." In the gradual encounter with Jesus she realized this internally, until one day, in praying the Our Father, she experienced a new birth, and she perceived in an insight that overturned all being, "not with my laughable intellect but with my whole being—that he exists". That is a thoroughly true insight, experience, repeatable and thereby verifiable experience—verifiable, to be sure, not in the attitude of the spectator, but only in entering into the experiment of life with God.

That was precisely the meaning of the catechumenate by which the early Church led man into contact with the Risen Lord: led by the witnesses step by step to take up the experiment of the path of Jesus, of life with him, and thus life with God. Gregory of Nyssa expressed that magnificently in his interpretation of the mysterious text saying that Moses, to be sure, had been able to see, not the face of God, but his back. To this he says, "To the one who asks about everlasting life, the Lord answered . . . 'Come, follow me!' (Lk 18:22). But whoever follows sees the back of the one he follows. And now Moses, who demands to see God, is instructed how to see God. To follow God wherever he leads is to see God."

The Easter bells invite us to this path. Again and again they meet man in the night. But where they touch the heart, night gives way to morning, darkness dissolves and becomes day. Even today. In this promise lies the joy of Easter.

Sarah's Laughter

The lightness and joy that most of us associate with the idea of Easter do not alter the fact that the inner significance of this day is far harder for us to appreciate than, for instance, the meaning of Christmas. Birth, childhood, the family—all this is part of our own experience. We are immediately attracted by the idea that God became a child, making little things great, rendering great things human, tangible, and close to us. According to our faith, God has stepped into the world in the birth at Bethlehem, and this causes a ray of light to fall even on those who cannot accept the message as such.

In the case of Easter it is different. Here, God has not entered into our familiar life; on the contrary, he has broken through its limitations and entered a new realm beyond death. Here, he does not enter into our pattern of life but goes before us into a vast, unknown expanse, holding the torch aloft to encourage us to follow him. However, since we are acquainted only with things on this side of death, there is nothing in our experience we can link with these tidings. We have no ideas to come to the aid of the words; we are feeling our way blindly in unknown territory and are painfully aware of our short-sightedness and cramped footsteps.

Translated by Graham Harrison.

It is thrilling, all the same, to learn, at least from the lips of someone who knows, of things that are of the greatest importance to all of us. Recent years have revealed a tremendous curiosity in the reports of people who have been clinically dead, who claim to have experienced what is beyond experience and seem to be able to speak of what lies behind the dark door of death. This inquisitiveness shows that the question of death is a burning topic to everyone. All these accounts leave us unsatisfied, however, because, after all, the people concerned were not really dead; they only underwent the special experience associated with a particular, extreme condition of human life and consciousness. No one can say whether their experience would have been confirmed had they been really dead. But he of whom Easter speaks—Jesus Christ—really "descended into hell". Jesus actually complied with the suggestion of the rich man: Let someone come back from the dead, and we will believe (Lk 16:27f.)! He, the true Lazarus, *did* come back so that *we* may believe. And do we? He did not come back with disclosures or with exciting prospects of the "world beyond". But he did tell us that he is "going to prepare a place" for us (Jn 14:2–3). Is this surely not the most exciting news in the whole of history, though it is presented without any fanfare?

Easter is concerned with something unimaginable. Initially, the event of Easter comes to us solely through the word, not through the senses. So it is all the more important for us to be won over by the immensity of this word. Because, however, we can think only by employing sense images, the faith of the Church has always translated the Easter message into symbols that point to things the word cannot express. The symbol of light (including the fire) plays a special part; the praise of the Paschal candle—a symbol of life in the midst of the darkened church—is actually praise of him who proved

victor over death. Thus the event of long ago is translated into our present time: where light conquers darkness, something of the Resurrection takes place. The blessing of water focuses on another element of creation, used as a symbol of the Resurrection: water can be a threat, a weapon of death. But living spring water means fruitfulness, building oases of life in the middle of the desert. Then there is a third symbol of a very different kind: the sung Alleluia, the solemn singing of the Paschal liturgy, shows that the human voice, as well as crying, groaning, lamenting, speaking, can also sing. Moreover, the fact that man is able to summon the voices of creation and transform them into harmony—does this not give us a marvelous intimation of the transformations that we, too, with creation, can undergo?

Is it not a wonderful sign of that hope which enables us to anticipate what is to come and also to receive it here and now? Nor is the season at which Easter is celebrated a chance matter, either. Via the Jewish Passover, the Christian Easter has its roots far back in the history of religions, in the realm of the so-called natural religions. I am always struck by the emphasis Jesus places during his earthly journey on his "hour". He is going toward his death, but he avoids it until this hour has come (see, for instance, Lk 13:31–35). In this way he quite deliberately links his mission with mankind's whole history of belief and with the signs to be found in creation. He ties the accomplishment of his mission to this particular feast and, hence, to the first full moon of spring. To those who look at things only from the point of view of technology or historicism, this must appear unintelligible and devoid of meaning. But Jesus thought otherwise. By linking his hour to the revolutions of the moon and the earth, to the cycles of nature, he situates his death in a cosmic context and, conversely, relates the cosmos to man. In the Church's great

festivals, creation, too, joins in; or rather, in these festivals we enter into the rhythm of the earth and the heavenly bodies and hear the message they have to give. Thus nature's new morning that marks the first full moon of spring is also a sign belonging genuinely to the Easter message: creation speaks of us and to us. We can understand ourselves, and Christ, properly only if we also learn how to listen to the voice of creation.

Today, however, I want to direct our attention to that symbol which was at the center of the Jewish Passover and thus naturally became the core of the Church's Easter symbolism, namely, the Paschal Lamb. It is remarkable how important a part is played in the Bible by the image of the lamb. We come across it in the very first pages, in the account of the sacrifice of Abel, the shepherd; and in the last book of Holy Scripture the Lamb is at the very center of heaven and earth. According to the Book of Revelation, the Lamb alone can open the seals of history. It is the Lamb, who appears as slain and yet lives, who receives the homage of all creatures in heaven and earth. The lamb that lets itself be killed without complaint is a symbol of meekness: Blessed are the meek, for they shall inherit the earth (Mt 5:5). The Lamb with his mortal wound tells us that, in the end, it is not those who kill who will be the victors; on the contrary, the world is sustained by those who sacrifice themselves. It is the sacrifice of him who becomes the "Lamb slain" that holds heaven and earth together. True victory lies in this sacrifice. It gives rise to that life which imparts a meaning to history, through all its atrocities, and which can finally turn them into a song of joy.

It is not through these passages, however, that I have come to realize the significance of the image of the lamb, but rather through that most puzzling story in the Bible which continues to scandalize its readers and thus spurs us on to a deeper

questioning about God and can lead us to a better under-
standing of his mystery. I refer to the story of the sacrifice of
Isaac. As he climbs the mountain, he sees that there is no
animal for the sacrifice. He asks his father about this and is
told that "God will provide" (Gen 22:8). Not until the very
moment when Abraham lifts up his knife to slay Isaac do we
grasp how truly he spoke: a ram is caught in a thicket and
takes the place of Isaac as a sacrifice. Jewish thought continu-
ally returned to that mysterious moment when Isaac lay
bound on the altar. Often enough, Israel was obliged to
recognize its own situation in that of Isaac, bound and ready
for the fatal knife, and was thus heartened to try to understand
its own destiny. In Isaac, Israel had, as it were, meditated upon
the truth of the words "God will provide." Jewish tradition
tells that, at the moment when Isaac uttered a cry of terror,
the heavens opened and the boy saw the invisible mysteries of
creation and the angelic choirs. This is connected with an-
other tradition, according to which it was Isaac who created
Israel's rite of worship; thus the Temple was built, not on
Sinai, but on Moriah. It is as though all worship originates in
this glimpse on the part of Isaac—in what he then saw and
afterward communicated. Finally, in this connection, there
are various interpretations of the name Isaac, which contains
the root "laughter". First of all, the Bible sees in the name an
allusion to the sad, unbelieving laughter of Abraham and
Sarah, who would not believe that they could still have a son
(cf. Gen 17:17; 18:12). But once the promise comes true, it
turns into joyful laughter; crabbed loneliness is dissolved in
the joy of fulfillment (Gen 21:6). Later tradition refers the
laughter no longer only to Isaac's parents but to Isaac himself.
And indeed, had he not grounds for laughter when the ten-
sion of mortal fear suddenly disappeared at the sight of the
trapped ram, which solved the riddle? Did he not have cause

to laugh when the sad and gruesome drama—the ascent of the mountain, his father binding him—suddenly had an almost comic conclusion, yet one that brought liberty and redemption? This was a moment in which it was shown that the history of the world is not a tragedy, the inescapable tragedy of opposing forces, but "divine comedy". The man who thought he had breathed his last was able to laugh.

Just as Jewish tradition continually returned to the story of Isaac, the Church Fathers also simply could not put this story down. They, too, asked what Isaac experienced at that final moment when he lay bound on the firewood. What did he see? Their answer is simpler and more realistic than that of the Jewish scholars. They say quite simply: He saw the ram that took his place and thus, at that moment, "redeemed" him. He saw the ram that thenceforward became the center of the Jewish cult as a whole. The Fathers, too, say that the Jewish cult ultimately aims to continue and to preserve the experience of that moment; it aims to achieve redemption by substitution. And they, too, are aware that Isaac, on seeing the ram, had good reason for laughing; the sight of the ram gave him back the laughter he had so recently lost.

The Fathers go one step farther, however. Isaac saw the ram: that is, he saw the sign of what was to come, of him who was to come as the Lamb. Seeing the lamb, he had caught sight of him who, for our sake, allowed himself to be caught in the thicket of history, who for our sake let himself be bound, who took our place and is our redemption. To that extent, according to the Fathers, Isaac did actually have a glimpse of heaven. His sight of this ram was a view of heaven opened. For in it he saw the God who provides and who stands waiting on the very threshold of death. In seeing the ram he saw the God who not only provides but provides himself in becoming the Lamb, so that man may become man

and may live. When Isaac caught sight of the ram in this last moment, he saw exactly what, on Patmos, John saw in the opened heavens. John describes it thus: "And between the throne and the four living creatures and among the elders, I saw a Lamb standing, as though it had been slain. . . . And I heard every creature in heaven and on earth and under the earth and in the sea, and all therein, saying, 'To him who sits upon the throne and to the Lamb be blessing and honor and glory and might for ever and ever!'" (Rev 5:6, 13). Isaac's sight of the lamb showed him what cult is: God himself provides his cult, through which he releases and redeems man, and gives him back the laughter of joy that becomes creation's hymn of praise.

Now you might say, what concern of ours are the Church Fathers and Jewish stories? Well, I do not think it is difficult to see that the Isaac of whom we are speaking is we ourselves. We climb up the mountain of time, bearing with us the instruments of our own death. At first the goal is far distant. We do not think of it; the present is enough: the morning on the mountain, the song of the birds, the sun's brightness. We feel we do not need to know about our destination, since the way itself is enough. But the longer it grows, the more unavoidable the question becomes: Where is it going? What does it all mean? We look with apprehension at the signs of death that, up to now, we had not noticed, and the fear rises within us that perhaps the whole of life is only a variation of death; that we have been deceived and that life is actually not a gift at all but an imposition. Then the strange reply, "God will provide", sounds more like an excuse than an explanation. Where this view predominates, where talk of "God" is no longer believable, humor dies. In such a case man has nothing to laugh about anymore; all that is left is a cruel sarcasm or that rage against God and the world with which

we are all acquainted. But the person who has seen the Lamb—Christ on the Cross—knows that God has provided. The heavens are not opened, none of us has seen the "invisible mysteries of creation and the angelic choirs". All we can see is—like Isaac—the Lamb, of whom the Apostle Peter says that he was destined before the foundation of the world (1 Pet 1:20). But this sight of the Lamb—the crucified Christ—is in fact our glimpse of heaven, of what God has eternally provided for us. In this Lamb we actually do glimpse heaven, and we see God's gentleness, which is neither indifference nor weakness but power of the highest order. It is in this way, and only thus, that we see the mysteries of creation and catch a little of the song of the angels—indeed, we can try to join with them, somewhat, in singing the Alleluia of Easter Day. Because we see the Lamb, we can laugh and give thanks; from him we also realize what adoration is.

Let us come back to the Church Fathers. As we have seen, they discerned, in the lamb, an anticipation of Jesus. Moreover, they say that Jesus is both the lamb and Isaac. He is the lamb who allowed himself to be caught, bound, and slain. He is also Isaac, who looked into heaven; indeed, where Isaac saw only signs and symbols, Jesus actually entered heaven, and since that time the barrier between God and man is broken down. Jesus is Isaac, who, risen from the dead, comes down from the mountain with the laughter of joy in his face. All the words of the Risen One manifest this joy—this laughter of redemption: If you see what I see and have seen, if you catch a glimpse of the whole picture, you will laugh! (cf. Jn 16:20).

In the Baroque period the liturgy used to include the *risus paschalis*, the Easter laughter. The Easter homily had to contain a story that made people laugh, so that the church resounded with a joyful laughter. That may be a somewhat superficial form of Christian joy. But is there not something

very beautiful and appropriate about laughter becoming a liturgical symbol? And is it not a tonic when we still hear, in the play of cherub and ornament in baroque churches, that laughter which testified to the freedom of the redeemed? And is it not a sign of an Easter faith when Haydn remarked, concerning his church compositions, that he felt a particular joy when thinking of God: "As I came to utter the words of supplication, I could not suppress my joy but loosed the reins of my elated spirits and wrote 'allegro' over the Miserere, and so on"?

The Book of Revelation's vision of heaven expresses what we see by faith at Easter: the Lamb who was slain lives. Since he lives, our weeping comes to an end and is transformed into laughter (cf. Rev 5:4f.). When we look at the Lamb, we see heaven opened. God sees us, and God acts, albeit differently from the way we think and would like him to act. Only since Easter can we really utter the first article of faith; only on the basis of Easter is this profession rich and full of consolation: I believe in God, the Father Almighty. For it is only from the Lamb that we know that God is really Father, really Almighty. No one who has grasped that can ever be utterly despondent and despairing again. No one who has grasped that will ever succumb to the temptation to side with those who kill the Lamb. No one who has understood this will know ultimate fear, even if he gets into the situation of the Lamb. For there he is in the safest possible place.

Easter, therefore, invites us not only to listen to Jesus but also, as we do so, to develop our interior sight. This greatest festival of the Church's year encourages us, by looking at him who was slain and is risen, to discover the place where heaven is opened. If we comprehend the message of the Resurrection, we recognize that heaven is not completely sealed off above the earth. Then—gently and yet with immense

power—something of the light of God penetrates our life. Then we shall feel the surge of joy for which, otherwise, we wait in vain. Everyone who is penetrated by something of this joy can be, in his own way, a window through which heaven can look upon earth and visit it. In this way, what Revelation foresees can come about: every creature in heaven and on earth and under the earth and in the sea, everything in the world, is filled with the joy of the redeemed (cf. Rev 5:13). To the extent that we realize this, the words of the departing Jesus—who, parting from us, is the coming Jesus—are fulfilled: "Your sorrow will turn into joy" (Jn 16:20). And, like Sarah, people who share an Easter faith can say: "God has made me laugh; every one who hears will laugh with me" (Gen 21:6).

The Ascension

The Beginning of a New Nearness

The evangelist Luke weaves into the history of Christ's Ascension a comment that never ceases to surprise me as often as I have tried to clarify it theologically. Luke says in his Gospel that the disciples were full of joy when they returned from the Mount of Olives to Jerusalem. That does not quite correspond to our normal psychology. The Lord's Ascension was the last appearance of the Risen One. The disciples knew they would no longer see him in this world. To be sure, this departure is not to be compared with that of Good Friday, when Jesus had apparently failed and all previous hopes must have appeared to have been greatly mistaken. The departure on the fortieth day after the Resurrection has in contrast to Good Friday something triumphal and reassuring about it. Jesus has indeed gone away this time, not into death, but into life. He is not defeated; but rather God has justified him. So there are without doubt grounds for joy. But even if intellect and will are happy, the feelings may still not necessarily join in. Even while understanding Jesus' victory, there could be emotional suffering from the loss of human proximity. The fear of being abandoned could increase, especially in light of the immense task that still lay ahead: going out into the unknown and giving witness to Jesus to a world that could see in the disciples only unhinged persons of little account from the country of the Jews.

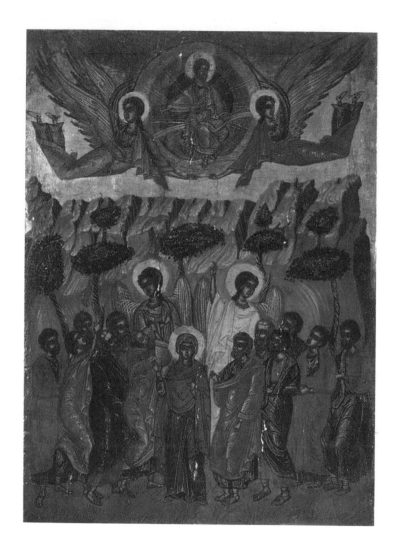

ASCENSION

Greek icon from the seventeenth century

But here we have, as an unshakable fact, the mention of the great joy of the homecomers. We will never be able completely to unlock the meaning of this word if we understand so little the joy of the martyrs: the song of a Maximilian Kolbe in the starvation bunker, the joyful praise to God that Polycarp spoke on the funeral pyre, and so many others. In the saints of charity, we find the same great joy particularly in moments when they perform the most difficult services for the sick and suffering—and praise be to God these are not only stories of the past. We can sense from these experiences something about how the joy of Christ's victory not only meets the intellect, but also communicates itself to the heart and only then is thereby truly received. Only when something of this has also arisen in us have we understood the feast of Christ's Ascension. What has happened here is the arrival of the finality of the redemption in the heart of man so that knowledge becomes joy.

We do not know in detail how that may occur. But Sacred Scripture gives us a few clues nevertheless. Luke tells us, for example, that Jesus revealed himself in the forty days after the Resurrection to the eyes and ears of the disciples by explaining to them the things of the kingdom of God. He then adds a third word by which he interprets the experience of being together in these days—a somewhat strange word that the German Ecumenical Bible translates as "common meal". Literally, however, it says the Lord had "eaten salt with them". Salt was the most precious gift of hospitality and so became synonymous with hospitableness. So one would have to translate rather: he received them in his hospitality, in a hospitality that is not just an external event, but rather means a participation in one's own life. Salt is, however, also a symbol of the Passion. It is a seasoning, and it is a preservative that counteracts decay, counteracts death. Whatever the

mysterious word may say, the intention is reasonably clear: Jesus had made the mystery perceivable to the senses and to the hearts of the disciples. It was no longer a mere idea. It still contained very little of understandable knowledge, but they were physically touched by the core of it. They knew Jesus and his good news no longer as something external to them, but rather it lived within themselves.

Yet a second note of the evangelist strikes me as important. He says that Jesus extended his hands and blessed them. In the blessing he disappeared. His last image is that of his extended hands, the gesture of blessing. The Ascension icon of the Christian East, which in its core reaches back to the earliest development of Christian art, has made this scene the actual center of the whole. Ascension is the gesture of blessing. The hands of Christ have become the ceiling that covers us and at the same time have become the effective power that opens the door of the world toward what is above. In blessing he goes, but also the opposite is true—in blessing he remains. That is henceforth the way he relates to the world and to us. He blesses; he has himself become blessing for us. So this word could perhaps best impart to us the center of the event and clarify the strange contradiction of a departure that is entirely joyful. The event that the disciples had experienced was blessing, and they leave as ones who have been blessed, not ones who have been abandoned. They knew that they were forever blessed and stood under blessing hands wherever they went.

Considered in this way, the note of Saint Luke is quite close to a few sentences in Jesus' farewell discourse reported to us by John. First, it is striking what role the mention of joy plays there. To be sure, the disciples must first go through the experience of sadness. Indeed, the experience of deprivation, the loss of companionship, is necessary so they can come to joy. "I will not leave you desolate; I will come to you" (Jn

14:18), and with this coming is meant the new experience of closeness, which Luke describes with the word "blessing". For this sentence of the farewell discourse corresponds to the other: "I will ask the Father, and he will give you another Counselor, to be with you for ever" (Jn 14:16). The theology of the Eastern Church has identified the prayer of the Lord for the other Counselor with the blessing of Ascension day: the blessing hands are also suppliant hands, praying hands. They are henceforth lifted to the Father and ask him nevermore to leave his own, that the Consoler might ever be with them in their midst. When we read Luke and John together, we may say the disciples knew precisely in seeing Jesus blessing and praying that now it is true: "I will not leave you desolate." They knew that now it is unquestionably the case: "I am with you always, to the close of the age" (Mt 28:20). They knew that now Christ always comes as blessing, that he now, so to speak, eats salt with them, that they will be and will remain blessed in all trials.

The liturgical texts of the Eastern Church emphasize yet a further aspect of this occurrence. It says there: "The Lord is risen in order to lift up the fallen image of Adam and to send us the Spirit that he might sanctify our souls." In the Ascension of Christ we are also dealing with the second part of *ecce homo*. Pilate showed the assembled mob the abused and mistreated Jesus, making reference thereby to the maltreated, trampled upon countenance of man per se. "Behold—the man", he said. Film and theater of today present us again and again—sometimes compassionately, often cynically, and sometimes with masochistic pleasure at the self-mockery— debased man in all stages of horror. That is man, they tell us again and again. The theory of evolution draws the line in reverse, showing us their discovery, the clay from which man originated, hammering it into us: That is man. To be sure, the

image of Adam is fallen; it lies in the mud and is muddied over and over again. But Christ's Ascension says to the disciples, says to us: The gesture of Pilate is only half-true and something less than that. Christ is not only the bloodied and wounded head; he is the ruler of the entire world. His rule does not mean the trampling of the earth but that its brilliance has been restored, to speak of God's beauty and power. Christ has raised the image of Adam: You are not simply dirt; you extend over all cosmic dimensions up to the heart of God. Christ's Ascension is the rehabilitation of man. It is not the one being beaten who is debased, but rather the one doing the beating. It is not the one being spit upon who is debased, but rather the one doing the spitting. The one scorned is not disgraced, but the one who scorns. It is not arrogance that enables man but rather humility. It is not self-importance that makes him great but rather the communion with God of which he is capable.

Christ's Ascension is therefore not a spectacle for the disciples but an event in which they themselves are included. It is a *sursum corda*, a movement toward the above into which we are all called. It tells us that man can live toward the above, that he is capable of attaining heights. More: the altitude that alone is suited to the dimensions of being human is the altitude of God himself. Man can live at this height, and only from this height do we properly understand him. The image of man has been raised up, but we have the freedom to tear it down or to let ourselves be raised. We do not understand man when we ask only where he comes from. We understand him only when we also ask where he can go. Only from his height is his essence really illuminated. And only when this height is perceived does there awaken an absolute reverence for man that considers him still holy even in his humiliation. Only from there can we really learn to love the human condition

[*Menschsein*] in ourselves and in the other. For this reason accusation should not become the most important word about man. To be sure, accusation is necessary as well, so that guilt is recognized as guilt and becomes differentiated from the right being of man. But the accusation alone is insufficient: if we isolate it, it becomes negation and, thereby, itself a way of degrading man.

For this reason it is also not right, as we sometimes hear it said today, that faith must keep mankind's subversive memory alive, which hinders us from resigning ourselves to the injustice of this world. Indeed, faith does teach us the memory of the Cross and of the Resurrection of Jesus Christ. But this memory is not subversive. It reminds us certainly that the image of Adam has fallen, but it reminds us above all that this image has been raised up again and that even as fallen ever remains the image of God's beloved creature. Faith hinders our forgetfulness. Indeed, it awakens in us the actual buried memory of our origin: that we come from God; and it adds the new remembrance that is expressed in the feast of Christ's Ascension: namely, that the actual true place of our existing is God himself and that we must ever view man from this vantage point. The memory of faith is in this sense a quite positive memory. It sets free again the positive basic measure of man. And recognizing this is a much more effective protection against the belittlement of man than the mere memory of negations that in the end can leave only contempt of man. The most effective counterforce to the corruption of man lies in the memory of his greatness, not in the memory of his defilement. Christ's Ascension impresses on us the memory of greatness. It immunizes us against the false moralism of the disparagement of man. It teaches us respect and gives us back the joy of being human.

If all this is taken into consideration, the claim that

Christ's Ascension is the canonization of a superseded cosmology disposes of itself. The issue is what is the measure of being human, not how many floors the universe has. The issue is God and man, the true height of being human, not the position of the stars. This insight must not, however, mislead us to think of Christianity as completely unworldly and to make faith purely a question of mental attitude. There is also a correct, meaningful relationship between faith and the entirety of the created world, for which, by the way, the old world-view can provide a signpost. That is not entirely easy to explain, since our ability to imagine has been changed by the world's use of technology. Perhaps a point of departure can be offered when we remember once again the classical type of Byzantine icon of Christ's Ascension. There, the fact that the Mount of Olives was the site of this event is suggested by a few olive branches that jut out of the silhouette dividing heaven and earth. In this way, first of all, the remembrance of the night of Gethsemane is touched upon: the place of fear becomes the place of confidence. Precisely there where the drama of death and its degradation were withstood from within, the renewal of man is accomplished. Indeed, there his true ascent begins. But the leaves of the olive tree speak also in and of themselves: they express the goodness of creation, the wealth of its gifts, the unity of creation and man, where they both are understood to be from the Creator. They are symbols of peace. Thus they are here symbols of a cosmic liturgy. The history of Jesus Christ is not only an occurrence between men on a dismal planet somewhere in the silence of the universe. This history comprises heaven and earth, the entire reality. When we celebrate the liturgy, it is not a kind of little family circle in which we draw on the mutual support of a visible community. The Christian liturgy has cosmic proportions: we join

creation's hymn of praise and at the same time lend creation a voice.

In conclusion, I would like to add yet a further thought, which this time results from the image tradition of the West. You are surely familiar with all those precious, naïve images in which only the feet of Jesus are visible, sticking out of the cloud, at the heads of the apostles. The cloud, for its part, is a dark circle on the perimeter; on the inside, however, blazing light. It occurs to me that precisely in the apparent naïveté of this representation something very deep comes into view. All we see of Christ in the time of history are his feet and the cloud. His feet—what are they? We are reminded, first of all, of a peculiar sentence from the Resurrection account in Matthew's Gospel, where it is said that the women held onto the feet of the Risen Lord and worshipped him. As the Risen One, he towers over earthly proportions. We can still only touch his feet; and we touch them in adoration. Here we could reflect that we come as worshippers, following his trail, close to his footsteps. Praying, we go to him; praying, we touch him, even if in this world, so to speak, always only from below, only from afar, always only on the trail of his earthly steps. At the same time it becomes clear that we do not find the footprints of Christ when we look only below, when we measure only footprints and want to subsume faith in the obvious. The Lord is movement toward above, and only in moving ourselves, in looking up and ascending, do we recognize him. When we read the Church Fathers something important is added. The correct ascent of man occurs precisely where he learns, in humbly turning toward his neighbor, to bow very deeply, down to his feet, down to the gesture of the washing of feet. It is precisely humility, which can bow low, that carries man upward. This is the dynamic of ascent that the feast of the Ascension wants to teach us.

The image of the cloud points in the same direction. It is reminiscent of that cloud which preceded Israel in its trek through the desert. By day it was cloud; by night, pillar of fire. Even "cloud" is an expression for a movement, for a reality we cannot catch and secure, for a direction that avails only when we follow it—for the Lord, who always goes ahead of us. The cloud is concealment and presence at the same time. Thus it has become a symbol of the sacramental signs in which the Lord precedes us, in which he both hides himself and lets himself be touched.

Let us turn back once again to our point of departure. The Ascension allowed the disciples to become glad. They knew they would no longer be alone. They knew they were blessed ones. The Church would also like to instill this knowledge in us in the forty days after Easter. The Church would like it not to become for us only a knowing of the intellect but rather a knowing of the heart, in order that that great joy might also overtake us that could no longer be taken away from the disciples. In order for knowledge of the heart to develop, encounter is necessary—an inner listening to the words of the Lord, an inner familiarity with him, as Scripture conveys it with the mention of the common eating of salt. The feast of Christ's Ascension invites us to this inner openness. The more we succeed, the more we understand the great joy that occurred on a day in which apparent departure was in truth the beginning of a new nearness.

The Holy Spirit and the Church

One often hears the complaint that in the Church too little is spoken of the Holy Spirit. Sometimes it goes so far as to say that there must be a certain symmetry between the speaking of Christ and speaking of the Holy Spirit. Everything said about Christ must correspond to what is said of the Holy Spirit. Whoever demands this forgets, however, that Christ and the Spirit belong to the triune God. He forgets that the Trinity is not to be understood as a symmetrical coexistence. If this were so, then we would simply be believing in three divinities, and we would thereby be fundamentally distorting what the Christian confession of the one God in three Persons holds. Here, as so often is the case, the liturgy of the Eastern Church can point us in a useful direction. The Eastern Church on Pentecost Sunday celebrates the feast of the Most Holy Trinity, on Monday the outpouring of the Spirit, and on the following Sunday, the feast of All Saints. This liturgical arrangement belongs close together and shows us something of the inner logic of faith. The Holy Spirit is not an isolated value or a value that can be isolated. It is according to his essence to direct us into the unity of the triune God. When we pass through the history of salvation from Christmas to Easter, Father and Son appear to us in contrast, in

63

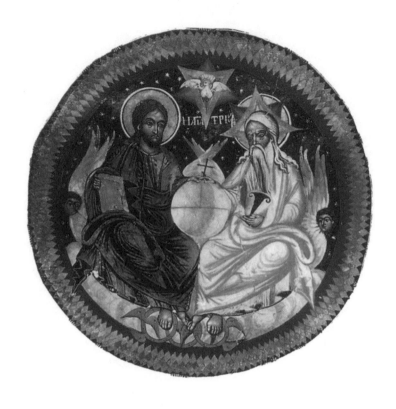

HOLY TRINITY

*Dome fresco in the portico to the trapezium in the Dochiariou Monastery,
Athos, sixteenth century*

mission and obedience. Now the Holy Spirit does not represent a third reality somewhere next to or between the other two. He leads us to the unity of God. Looking to him means overcoming distinction and recognizing the ring of eternal love that is the highest unity. He who wants to speak of the Spirit must speak of the Trinity of God. If the doctrine of the Holy Spirit is supposed to be in a certain respect a corrective to a one-sided Christocentrism, then this corrective consists in the Spirit teaching us to see Christ entirely in the mystery of the trinitarian God as our way to the Father in perpetual conversation of love with him.

The Holy Spirit points to the Trinity, and thereby he points to us. For the trinitarian God is the archetype of the new united humanity, the archetype of the Church, as the prayer of Jesus may be seen as its word of institution: "that they may be one, even as we are one" (Jn 17:11b, cf. 21f.). The Trinity is measure and foundation of the Church. The Trinity brings the word of creation day to its goal, "Let us make man in our image, after our likeness" (Gen 1:26). In the Trinity, mankind, which in its disunity became a counter image of God, should become once again the one Adam, whose image, as the Fathers say, was defaced by sin and now lies about in pieces. The divine measure of man should again come to prominence, unity, in it, "as we are one". So the Trinity, God himself, is the archetype of the Church. Church does not mean another idea in addition to man, but rather man on the way to himself. If the Holy Spirit expresses and is the unity of God, then he is the real vital element of the Church in which distinction is reconciled in togetherness and the dispersed pieces of Adam are fit together again.

For this reason the liturgical representation of the Holy Spirit begins with the celebration of the Holy Trinity. Such a celebration tells us what the Spirit is: nothing in himself that

one could put alongside others, but rather the mystery that God in love is entirely one, single, and that he is, however, at the same time counterpart, exchange, community. And from the Trinity, the Spirit tells us what God's idea for us was: unity according to the image of God. He also tells us, however, that we men among ourselves can become one only when we find ourselves in a higher unity, as it were, in a third party. Only when we are one with God can we be united among ourselves. The way to the other leads over God. Without this medium of our unity, we would remain eternally separated from one another by abysses that no good will can bridge.

Everyone who experiences his humanity with alert senses perceives that we are not speaking of mere theological theories. The ultimate inaccessibility of the other, the impossibility of giving oneself to another and understanding one another for any length of time has perhaps seldom been learned so dramatically as in the twentieth century. "Life means being lonely, no one knows the other, everyone is alone", Hermann Hesse formulated. When I speak with the other, it is as if a wall of translucent glass stood between us: we see each other, and yet we do not see each other; we are near to each other, and yet we cannot come near to each other. This is how Albert Camus described the same experience.

Pentecost, the presence of the trinitarian mystery in our human world, is the answer to this experience. The Holy Spirit is concerned with the basic human question: How can we come to each other? How can I remain myself, respect the otherness of the other, and, nevertheless, step outside the fence of loneliness and touch the other from inside? The Asiatic religions have answered this with the thought of nirvana. As long as there is an ego, it will not work, they say. The ego is itself the prison. I have to dissolve the ego, leave behind the personality as prison and as place of un-redemption, let

myself fall into the void as if into the true universe. Redemption is dis-solution [*Ent-werdung*], and it must be exercised: the return to the void, the shedding of the ego as the sole true and final liberation. Whoever experiences day by day the burden of the ego and the burden of the Thou can understand the fascination of such a program. But is the void really better than being? Is the dissolution of the person better than his fulfillment?

Mere activism is no answer to such mystic flight. On the contrary, it brings about this flight. Then all new mechanisms that it creates become only new prisons if I and Thou are not reconciled. I and Thou, however, cannot reconcile if man remains unreconciled with his own I. But how should the I accept it, this ever-thirsty and covetous I, which calls for love, for the Thou, and at the same time feels wounded, threatened, and constricted by the Thou? In contrast to the great desire of the Asiatic religions, incidentally, the modern techniques of group dynamics, of the reconciliation of man with himself and with the Thou, are only poor substitutes for solutions despite their ingenious artifice. I and Thou are put, as it were, over a low flame and become accustomed to rules in order to take as little notice of each other as possible and in order not to have friction. Their divine passion is reduced to a couple of drives, and man is treated like an apparatus whose directions for use must be known. One tries to solve the problem of being human by denying man per se and treating him as a system of processes that one can set up and learn to control.

Now you may perhaps ask, what does all this have to do with the Holy Spirit and the Church? The answer is that the Christian alternative to nirvana is the Trinity, that ultimate unity in which the distinction between I and Thou is not withdrawn but joined to each other in the Holy Spirit. In

God there are Persons, and so he is precisely the realization of ultimate unity. God did not create the person so that he might be dissolved but so that he might open himself in his entire height and in his innermost depth—there, where the Holy Spirit embraces him and is the unity of the divided persons. Now that sounds perhaps very theoretical. We must try step by step to approach the program of life that is contained within it.

We are on this path if we consider once again the progress of the liturgical celebrations of the Eastern Church. After the Feast of the Trinity on Pentecost Sunday, the outpouring of the Spirit, the foundation of the Church, is celebrated on Monday. On the following Sunday, the feast of All Saints is celebrated, as we said before. The communion of saints, that is, mankind formed according to the trinitarian pattern of unity, the future city that is still coming to be and which we try to build with our lives: the communion of saints is the ideal image of the Church, so to speak, at the end of the week, at whose beginning stands the earthly Church that began in the room of the Last Supper in Jerusalem. The Church in time is suspended between this Church of the beginning and the ever-growing Church of the end. In the artistic tradition of the East, the Church of the beginning, the Church of Pentecost, is the icon of the Holy Spirit. The Holy Spirit becomes visible and depictable in the Church. If Christ is icon of the Father, the image of God, and at the same time the image of man, so the Church is the image of the Holy Spirit. From here we can understand what the Church actually is in the deepest part of her nature: namely, the overcoming of the boundary between I and Thou, the union of men among themselves through the radical transcendence of self into eternal love. Church is mankind being brought into the way of life of the trinitarian

God. For this reason she is not something that belongs to a group or a circle of friends. For this reason she cannot become a national Church or be identified with a race or a class. She must, if this is true, be catholic in order "to gather into one the children of God who are scattered abroad", as John's Gospel (11:52) formulates.

The word "dis-solution", which describes the spiritual process of the Asiatic religions, may be little suited to represent the Christian way. It is true, however, that a breaking and a being broken belong to Christianity, just as must happen to the dead grain of wheat so that upon opening it brings forth fruit. Becoming a Christian is becoming united. The shards of the broken image of Adam must be fitted together again. Being a Christian is not self-affirmation but rather a departure into the great unity that envelops mankind of all places and times. The flame of eternal longing is not extinguished but rather directed so that it is united with the fire of the Holy Spirit. The Church does not begin, therefore, as a club; rather, she begins catholic. She speaks on her first day in all languages, in the languages of the planet. She was first universal before she brought forth local churches. The universal Church is not a federation of local churches but rather their mother. The universal Church gave birth to the particular churches, and these can remain church only by continuously losing their particularity and passing into the whole. Only in this way, only from the whole, are they icons of the Holy Spirit, who is the dynamism of unity.

If we speak of the Church as the icon of the Holy Spirit and the Holy Spirit as the Spirit of unity, we may not, however, overlook a noteworthy characteristic of the account of Pentecost. It says there: The tongues of fire separated; one of them rested on each of them (Acts 2:3). The Holy Spirit has been given to each one personally and to each one in his own

way. Christ assumed human nature, that which binds us all and from which he binds us. The Holy Spirit, however, has been given to each as a person: through him, Christ becomes a personal answer for each of us. The unification of men as the Church should accomplish it does not occur through the extinguishing of the person but rather through his completion, which means his infinite openness. For this reason, on the one hand, the principle of catholicity belongs to the constitution of the Church. No one acts from merely his own will and his own genius. Everyone must act, speak, think, from the communion of the new We of the Church that stands in intercommunion with the We of the triune God.

But precisely for this reason, on the other hand, it is true that no one acts only as a representative of a group and of a collective system, but rather each stands in personal responsibility of conscience opened and purified in faith. The elimination of arbitrariness and egotism should not be accomplished in the Church through proportional representation of groups and majority constraint but rather through conscience formed from faith, conscience that creates not from one's own but rather from the faith received in common. In his farewell discourse, the Lord describes the essence of the Holy Spirit with these words: "He will guide you into all the truth; for he will not speak on his own authority, but whatever he hears he will speak, and he will declare to you the things that are to come" (Jn 16:13). Here the Spirit becomes the icon of the Church. Through the description of the Holy Spirit the Lord clarifies what the Church is and how she must live in order to be herself. Speaking and acting in a Christian way is accomplished in this way: Never be only I myself. Becoming Christian means receiving the whole Church into oneself, or, rather, allowing oneself to be taken up into her. When I speak, think, act, I do so as a Christian

always in the whole and from the whole. Thus the Spirit comes to the Word, and thus men come together. They come outwardly to one another only if they came to one another inwardly: if I have become inwardly broad, open, and large; if I have received the others through my co-believing and co-loving so that I am no longer ever alone but rather my whole essence is characterized by this "co-".

Such speaking from hearing, from receiving, and not in one's own name, may at first glance hinder the ingenuity of the individual. It restricts it, to be sure, if ingenuity is only an exaggeration of the individual that tries to extend itself to a kind of divinity. The knowledge of truth and progress does certainly not, however, hinder this way of thinking. The Holy Spirit thus leads by acting in the whole truth, in the not yet spoken truth of Jesus, and precisely there he also announces the future: We do not receive new knowledge through closure of the I. Truth discloses itself only in thinking with him what was known before us. The greatness of man depends on the measure of his ability to share. Only in becoming small, in participating in the whole, does he become great.

Paul summarizes this in a wonderful formula when he describes his conversion and baptism with the words "It is no longer I who live, but Christ who lives in me" (Gal 2:20). Being a Christian is essentially conversion, and conversion in the Christian sense is not the changing of a few ideas, but rather a process of death. The limits of the I are broken. The I loses itself in order to find itself anew in a larger subject that spans heaven and earth, past, present, and future, and therein touches truth itself. This "I and no longer I" is the Christian alternative to nirvana. We could also say: The Holy Spirit is this alternative. It is the power of opening and fusing into that new subject that we call the Body of Christ or the Church.

Here we all see, to be sure, that the coming together is no easy process. Without the courage of conversion, without letting oneself be broken open like the grain of wheat, it is not possible. The Holy Spirit is fire; whoever does not want to be burned should not come near him. But he must then also know that he is sinking into the deadly loneliness of the closed I and that all communion that is attempted at the fire finally remains only a game, an empty appearance. "Whoever is near to me is near to the fire" is a non-biblical saying of Jesus as transmitted to us by Origen. It refers to the relationship between Christ, Holy Spirit, and Church in an inimitable way.

Let me close with a word of Saint John Chrysostom that goes in the same direction. It follows the account in the Acts of the Apostles in which Paul and Barnabas healed a lame person in Lystra. The excited crowd saw in the two peculiar men who had such power a visit of the gods Zeus and Hermes. The crowd called the priests and wanted to sacrifice a bull. Paul and Barnabas are horrified and call to the crowd: "We also are men, of like nature with you, and bring you good news" (Acts 14:8–18). Chrysostom mentions in this regard: Correct, they were men like others, but different from them, too, for a tongue of fire was added to their human nature. That constitutes the Christian—that a tongue of fire is given to him, to his human existence. Thus Church originates. She is given to each one quite personally. He is Christ as this person in a singular and unrepeatable way. He has "his Spirit", his tongue of fire, so much so that we refer to this spirit of the other when we greet him liturgically: "and with your spirit". The Holy Spirit has become his spirit, has become his tongue of fire. But because he is thus the One, we can, through him, address each other, build with each other the one Church.

A tongue of fire has been added to being human. We must now correct this expression. Fire is never something that is simply due to another and therefore exists beside him. Fire burns and transforms. Faith is a tongue of fire that burns us and melts us so that ever more it is true: I and no longer I. Whoever, of course, meets the average Christian of today must ask himself: Where is the tongue of fire? That which comes from Christian tongues is unfortunately frequently anything but fire. It tastes therefore like stale, barely lukewarm water, not warm and not cold. We do not want to burn ourselves or others, but in this way we keep distant from the Holy Spirit, and Christian faith deteriorates into a self-made world-view that as far as possible does not want to infringe on any of our comforts and saves the sharpness of protest for where it can hardly disturb us in our way of life. When we yield to the burning fire of the Holy Spirit, being Christian becomes comfortable only at first glance. The comfort of the individual is the discomfort of the whole. When we no longer expose ourselves to the fire of God, the frictions with one another become unbearable and the Church is, as Basil expressed it, torn by the shouts of factions. Only when we do not fear the tongue of fire and the storm it brings with it does the Church become the icon of the Holy Spirit. And only then does she open the world to the light of God. Church began as the disciples assembled and prayed together in the room of the Last Supper. Thus she begins again and again. In prayer to the Holy Spirit we must call for this anew each day.

Apse mosaic of San Clemente Basilica in Rome (detail)

Corpus Christi

The Apse Mosaic of San Clemente in Rome

If we enter the historically rich church of Saint Clement's in Rome by way of the atrium, which, with its walkway of columns and the fountain in the middle, reminds us of the plan of the ancient Roman house, we are immediately seized by the sight of the great apse mosaic, with its golden background and shining colors. Our eye remains fixed on the picture of Christ in the middle. Christ has inclined his head and given his spirit into the hands of his Father. A great peace emanates from his face, from his entire figure. If we were to seek a title for this depiction of the Crucified, words like reconciliation and peace would immediately occur to us. Pain is overcome. Nothing of wrath, of bitterness, of accusation lies in the picture. The biblical saying that love is stronger than death can be seen here. Death is not the main thing we see. We see love that through death is not abolished but rather stands out more than ever. Earthly life is extinguished, but love remains. The Resurrection thus shines already through the scene of crucifixion.

If we linger before the mosaic, we notice that this Cross is in reality a tree, from beneath which four sources of water originate, at which deer slake their thirst. The thought of the four rivers of paradise arises, and the phrase in the psalm

comes to mind: "As a deer longs for flowing streams, so longs my soul for you, O God" (Ps 42:1–2). The tree that comes from living waters is fertile. We now notice that the rich network of branches that fills the entire breadth of the picture is not simply an ornament. It is a great vine whose branches grow forth from the roots and limbs of the tree of the Cross. They extend over the whole world in great circling motions, drawing it into itself. The world itself becomes a single large vineyard. Between its shoots and amid its coils, the fullness of historical life stirs. The work of shepherds, of peasants and monks, of animals and men of all kinds, the whole colorful diversity of existence, we find depicted in images full of fantasy and *joie de vivre*.

But there is still something else. The Cross not only grows in breadth. It has its height and its depth. We have already seen that it reaches below into the earth, waters it, and brings it to bloom. Now we must still regard its height. From above, out of the mystery of God, the hand of the Father reaches down. Thereby movement comes into the image. On the one hand, the divine hand appears to lower the Cross from the height of the eternal in order to bring the world life and reconciliation. But it draws upward at the same time. The descent of God's goodness brings the whole tree, with all of its branches, into the ascent of the Son, into the upward dynamic of his love. The world moves from the Cross upward to the freedom and expanse of the promises of God. The Cross creates a new dynamic: the eternal, futile circling around what is always the same, the vain circular motion of endless repetition, is broken open. The descending Cross is, at the same time, the fishhook of God, with which he reels up the entire world to his height. No longer circling but ascent is now the direction of history and human life. Life has received a destination; it goes with Christ to the hands of God.

But now we must ask: Is all of that true? Or is this one of the never-fulfilled utopias with which mankind attempts to console itself over the vanity of its history? Does any reality stand behind the image? Can there be a reconciled world that has become life's great garden of paradise? Two considerations may help us find an answer. The artist has not taken the picture of the world as God's vineyard, growing out of the Cross, without good reason. He is thinking of the words of Christ: "I am the vine, you are the branches" (Jn 15:5). The Cross as vine points us from the mosaic below to the altar, on which the fruit of the earth again and again is changed into the wine of the love of Jesus Christ. In the Eucharist the vine of Christ grows into the whole breadth of the earth. In its worldwide celebration, God's vine extends its circles over the earth and carries its life in fellowship with Christ. In such a way the image itself shows us the way to reality: Let yourself be drawn into the vine of God, it tells us. Give your life over to the holy tree that grows ever new from the Cross. Become a branch of it yourself. Keep your life in the reconciliation that comes from Christ, and let yourself be drawn upward by him.

When the apse mosaic of San Clemente was created, there was as yet no feast of Corpus Christi. The sense of that day is, however, wonderfully represented here. For it shows, indeed, how the Eucharist spans the world and transforms it. The Eucharist belongs not only in the Church and to a closed community. The world should become eucharistic, should live in the vine of God. But that is Corpus Christi: to celebrate the Eucharist cosmically; to carry it even to our streets and squares so that the world, from the fruit of the new vine, may receive healing and reconciliation through the tree of life of the Cross of Jesus Christ. We celebrate the feast in this sense. Its procession is like a loud call to the living God: Yes,

fulfill your promises. Let your vine grow over the earth, and let it become the place of reconciled life for us all. Detoxify this world through the waters of life, through the wine of your love. Do not let your earth shatter from hate and from man's presumption of omniscience. You, Lord, are yourself the new heaven, the heaven in which God is a man. Give us the new earth in which we men become branches of you, the tree of life, steeped in the waters of your love and taken up into the ascent to the Father, who alone is the true progress we all await.

Portiuncula

What Indulgence Means

When you travel to Assisi from the south, you encounter first, in the plain that extends before the city, the majestic basilica of Santa Maria degli Angeli, from the sixteenth and seventeenth centuries, with a classicistic façade from the nineteenth century. To be perfectly frank, it leaves me cold. The simplicity and humility of Saint Francis can hardly be sensed in this edifice furnished with such grand gesture. We find what we are looking for, however, in the middle of the basilica: a medieval chapel in which old frescoes tell of salvation history and of the history of Saint Francis, which took place in part on this site. In this low and poorly illuminated space we find something of calmness and emotion before the faith of centuries that found asylum and direction here. At the time of Saint Francis the surrounding land was wooded; it was like a swamp and uninhabited. Francis, in the third year of his conversion, came upon this little church that had fallen into ruin. It belonged to the Benedictine Abbey of Subasio. Just as he had previously restored by the work of his hands the churches of San Damiano and San Pietro, so Francis also did now with the Portiuncula chapel, which was dedicated to the Mother of God of the angels, in which he honored the Mother of all goodness. The run-down state of these various

little churches must have appeared to him as a sad symbol for the actual state of the Church. He still did not know that he was preparing himself with the restoration of these buildings for the renewal of the living Church. But here precisely in this chapel he now received the final call that gave form to his mission and resulted in the Order of Friars Minor, which was not even conceived of as an order but rather a movement for evangelization that should gather anew the people of God for the returning Lord.

Something happened to Francis that was much like what had happened to Saint Anthony of Egypt in the third century: he heard in the liturgy the Gospel about the sending out of the Twelve by the Lord, who gave them the charge to proclaim the kingdom of God and to set out without possessions and worldly securities. Francis had not completely understood the text at first, so afterward he had the priest clarify it especially for him, and then it became clear to him: That is my mission. He took off his shoes, retained only a tunic, and readied himself to proclaim the kingdom of God and repentance. Now little by little others joined him who, again like the Twelve, went from place to place and proclaimed the gospel. It meant joy for them, as it did for Francis, joy of the new beginning, joy through conversion, through the courage to repent. Portiuncula became for Francis the place in which he finally comprehended the Gospel, because he no longer surrounded it with theories and clarifications but only wanted to live it literally, because he noticed that these were not words of the past but words that were quite personally said to him. For this reason it was in the Portiuncula that he gave the habit to Saint Clare and thereby founded the order of women who, by praying, bore from within the evangelizing mission of the men. For this reason, too, he had himself brought there to die.

Portiuncula means little portion, the little piece of land. Francis did not want the Benedictines to give it to him; rather, he wanted them only to lend it to him for his confreres; and he wanted it precisely so that, as something not his own, it should express what was characteristic and new in his movement. The passage of Psalm 16 should apply here, which in the Old Covenant expressed the special nature of the priestly tribe of Levi, which belonged to no land but whose land was God himself alone ("The Lord is my chosen portion and my cup. . . . Yes, I have a goodly heritage" [16:5, 6]).

Portiuncula is first of all a place, as we saw, but through Francis of Assisi it became a reality of spirit and of faith, a reality that is physically attached, so to speak, to the place and itself becomes a place that we can enter, but with which we enter at the same time the history of faith and its ever-effective power. That Portiuncula reminds us not only of a great past history of conversion, that it does not represent a mere idea but rather always draws us into the living connection between repentance and grace, is quite essentially related to the so-called Portiuncula indulgence that is correctly called the forgiveness of Portiuncula. What should we understand by this? According to a tradition that admittedly first appeared at the end of the thirteenth century, Francis of Assisi visited the just elected Pope Honorius III in July 1216 in nearby Perugia and put to him an unusual request: that the Pope might grant all who visit the little church of Portiuncula full remission of guilt and punishment for their life up until then, if they have confessed and repented of their sins.

The Christian of today will ask himself what such a forgiveness might mean if sorrow and confession are presupposed. In order to understand that, we must first make clear that at this time, despite many changes, nevertheless essential elements of the ancient Church discipline of

penance continued. Part of this was the conviction that for-
giveness after baptism could not be attained simply in the act
of absolution; rather, as before in the preparation for bap-
tism, it demanded a real transformation of life, an inner
turning away from evil. The sacramental act had to be joined
to an act of existence with a real working off of guilt, which
is called penance. Forgiveness does not mean that this exis-
tential process is superfluous, but rather that it receives a
meaning, that it is accepted.

At the time of Saint Francis the main form of penance
given by the Church in connection with forgiveness was the
undertaking of a great pilgrimage—to Santiago, to Rome,
and especially to Jerusalem. The long, dangerous, and diffi-
cult way to Jerusalem could very well become an inner way
for many. It also had, however, a wholly practical effect: the
associated donations in the Holy Land became the most im-
portant source for the upkeep of the Church and of Chris-
tians. We should not turn up our noses too readily: penance
had thereby acquired a concrete social component. If now
Francis—as tradition ascribes to him—asks that all of this
could be satisfied by a prayerful visit to the holy place of
Portiuncula, then something really new was involved here: a
substitution, an indulgence that had to change the entire
nature of penance. One can easily understand that the cardi-
nals were displeased about this concession by the Pope and
were afraid for the maintenance of the Holy Land so that the
forgiveness of Portiuncula was at first limited to one day in
the year, the dedication day on August 2.

But now there is the question: Could the Pope do that so
simply? Can a pope dispense from an existential process as it,
along with the great penance of the Church, was understood?
Naturally not. That which is an inner requirement of human
existence cannot be made superfluous by an act of law. But

that was not at all the point. Francis, who had discovered the poor and poverty, was concerned with his request for those simple men laden with guilt who had neither the means nor the energy to make a pilgrimage into the Holy Land. These could give nothing but their faith, their prayer, their readiness to live their poverty from the gospel. In this sense the Portiuncula indulgence is the penance of those laden with guilt whose life itself already imposes sufficient penance. No doubt an internalization of the idea of penance was now generally involved, in which the necessary perceptible expression was not of course simply missing, because the pilgrimage to the simple and humble place of Portiuncula still belonged to it, which should always be henceforth an encounter with the radicalism of the gospel, as Francis had learned it in this place. It is undeniable that the danger of abuses was associated with the form of indulgences that gradually developed here, as history teaches us drastically enough. But when, in the end, we dwell only on the abuses, then we have fallen prey to a loss of memory and a superficiality with which we above all harm ourselves. For as always the great and pure is more difficult to see than the coarse and lowly.

Naturally I cannot now spread out the entire network of experiences and insights that has developed from the event in the Portiuncula. I only want to try to draw out the essential threads. After the granting of this special indulgence, a further step immediately took place. It was precisely the simple and humble man of faith who posed the question to himself: Why only for me? Can I not pass on in the spiritual realm just as in the material realm what was given to me? The thought was directed above all to the poor souls, the people who had been close, who had gone before into the other world, and whose fate could not remain a matter of

indifference. The weaknesses and mistakes of dear ones were well known; perhaps they had even caused personal suffering. Why should one not worry about them? Why not try to do good to them beyond the grave and, if possible, come to their aid and assistance on the dangerous journey of the soul. A primal feeling of mankind is involved here that has been given varied expression throughout human history in cults of ancestors and the dead. Christian faith has not simply declared all this to be false but rather has purified it and allowed it to step forth in its pure meaning. "If we live, we live to the Lord, if we die, we die to the Lord" (Rom 14:8). That means that the actual limit is no longer death but rather belonging or not belonging to the Lord. If we belong to him, then we are together through him and in him. For this reason, which was the quite logical requirement, there is love beyond the limits of death. And so the question of whether something of the given power of forgiveness could be passed on even over there was answered with the formula: Yes, it could be, namely, *per modum suffragii*, by way of intercession. Thus a special intensity was given to the Church's perennial practice of praying for the dead. And it was this consent that in fact allowed the indulgence to become a great invitation to prayer, despite all abuses and misunderstandings. Here I must add that the original indulgence connected to the Portiuncula location in the course of time was extended, first, to all Franciscans and, finally, to all parish churches for the second of August. From my youth I recall the Portiuncula day as a day of great interiority, as a day of the reception of the sacraments and as a day of prayer. In the square in front of our parish church a singular solemn stillness prevailed on this day. People went constantly in and out of the church. One sensed that Christianity is grace and that it is made available in prayer. Quite independent of all theories of indulgence, this was thus a worldwide

day of faith and a day of quiet confidence, of a prayer that in a special way was sure to be heard, that above all applied even to the dead.

But in the course of time yet a further thought has arisen that, while it may seem very strange to us today, contains an important truth. The more the indulgence was understood as advocacy for others, the more another thought came to the fore that justified the new form theologically and at the same time developed it further. Praying for those who have gone before us drew our thinking to the communion of saints and the spiritual exchange of gifts. Then you will ask: What will this mean, then? Is that not a nonsensical religious commercialism? The question became sharper, as I remember, because one spoke in fact of the treasury of the Church, which consisted of the good deeds of the saints. What is that supposed to mean? Must not every man be responsible for himself? What use should the possible good works of another be for me? So we ask because we still live in the narrow individualism of modern times, despite all socialist ideas. In fact, however, no man is closed in on himself. We all live interdependently, not only materially, but also spiritually and morally. First let us make that clear negatively. There are men who not only destroy themselves but also corrupt others with them and leave behind powers of destruction that drive whole generations into nihilism. If we think of the great seducers of our century, we know how real this is. The negation of the one becomes a contagious disease that carries others away. But, God be praised, this is not only true in the negative. There are people who leave behind, so to speak, a surplus of love, of perseverance in suffering, of honor and truth that captures others and sustains them. In the innermost recesses of existence, there really is such a thing as taking another's place. The entire mystery of Christ rests on this.

Now one can say: Good, there is such a thing. But the surplus of Christ's love is sufficient; it does not need anything added to it. It alone redeems, and everything else would be arrogance, as if we would have to add something from our finite love to his infinite love. That is correct, but still not completely correct. For it belongs to the greatness of Christ's love that he does not leave us in the state of being a passive receiver but involves us in his work and suffering. The famous text in the Letter to the Colossians says this: "In my flesh I complete what is lacking in Christ's afflictions for the sake of his body" (Col 1:24). I would like, however, also to refer to another New Testament text where it seems to me this is wonderfully expressed. The Revelation of John speaks of the bride, of the Church, in whom saved mankind is represented par excellence. While the whore Babylon appears dressed with ostentatious jewelry and with everything that is expensive and lavish, the bride wears only a simple garment of white linen, admittedly of the especially pure, shining Byssus linen, which is of great value. The text says: "The fine linen is the righteous deeds of the saints" (19:8). In the lives of the saints is woven the gleaming white Byssus that is the robe of eternity.

Let us speak without imagery. In the spiritual realm everything belongs to everyone. There is no private property. The good of another becomes mine, and mine becomes his. Everything comes from Christ, but because we belong to him, what is ours becomes his and attains healing power. That is what is meant by talk of the treasury of the Church, the good deeds of the saints. To pray for an indulgence means to enter into this spiritual communion of gifts and to put oneself at its disposal. The turn in the concept of penance that began in Portiuncula has logically led to this point. Even spiritually no one lives for himself. And concern about the salvation

of one's soul is freed from fear and egotism only when it becomes concern about the salvation of others. Therefore, Portiuncula, and the indulgence that originated there, is a charge to place the salvation of the other above my own and thereby to find myself. A charge to ask, no longer: Will I be saved, but rather: What does God want from me so that others are saved? Indulgence points to the communion of saints, to the mystery of substitution, to prayer as the way to become one with Christ and his mind. He invites us to weave with him the white garment of the new humanity that in its simplicity is true beauty.

Finally, the indulgence is a lot like the church of Portiuncula. Just as we have to go through the somewhat alienating coldness of the great edifice in order to find in the center the humble little church that touches our heart, so we must go through the turns of history and of theological ideas to that which is quite simple—to prayer, by which we let ourselves fall into the communion of saints in order to work with them for the surplus of good vis-à-vis the apparent omnipotence of evil, knowing that, finally, all is grace.

*Faithful seeking help at the tomb of Saint Wolfgang in Regensburg,
painting by Jan Pollak, circa 1500*

Wolfgang of Regensburg

A European Saint

Today, sanctity is not a theme that seems especially attractive or important to people. What we seek today sounds much more sober, much more modest: credibility. Our century has seen, time and again, the fall of the powerful, who formerly seemed to stand in unassailable heights and now, suddenly, robbed of their glamour, sit in the defendant's dock of history. Trust is destroyed time and again, and so the courage to trust gradually threatens to vanish. The slanderers of men and the slanderers of God, the Creator, find ample opportunity: One need only peel back the beautiful veneer, they say, and then behind all morality and dignity the same baseness surfaces. Authority becomes gradually impossible, and at first that seems to be a victory for freedom. But in reality the world becomes only darker and poorer when trust can no longer be proffered. For this reason we will always be on the lookout for credible persons who are inside what they project outside. Only when we find them can political moroseness and ecclesial fatigue be overcome.

What, actually, should the credible politician, like the credible shepherd, look like? In a similar crisis of trust, Plato said that the blindness of average politics is due to the fact that their representatives fight for power "as if it were a great

good". The real statesman must be a man who has seen
through this striving for semblance and appearance. He must
be a person who understands politics to be service and accepts
it as a burden, as a renunciation of the greater, which he has
tasted: the beauty of knowing, being free for truth. The crite-
ria for the right shepherd in the Church are not at all essen-
tially different. Whoever would seek the priesthood or office
of bishop as an increase in power and prestige has fundamen-
tally misunderstood it. Whoever wants above all to become
something himself with such offices will always be the slave of
public opinion. He must flatter in order to maintain his im-
portance. He must accommodate. He must agree with people.
He has to accommodate himself to the changing currents and
thus he becomes devoid of truth, for he must condemn to-
morrow what he praised today. Then he no longer really loves
people at all, but in the end loves only himself, although at the
same time he loses even himself to the opinion that happens
to be the stronger. I do not need to continue with such de-
scriptions. Unfortunately, we know such behavior clearly
enough from various instances in public life.

Let us return to the question of the credible shepherd.
What would he look like? Correspondence between outside
and inside belongs to credibility. But that is not enough. For
an evil person who openly professes to be such is also credible
in this sense. Proper credibility requires that the inner life of
this person correspond to the true sense of being human. We
could simply say: Whoever wants to appear good outwardly
must first, above all, be good interiorly. And good is the man
who is as God intended him to be. Good is the man who is
pleasing to God; the man in whom some of God's light
flashes. Good is the man who does not cover the light of God
with his own I, who does not put himself first but rather steps
aside to let God shine through. In this way the path leads on

its own from the demand for credibility back to the word "sanctity", when we understand it correctly only in its original simplicity.

What we have just suggested, however, actually applies to every person. For anyone who wants to serve the flock of Christ, these general indications must assume a quite specific form corresponding to this mission. I have said already that a priest or bishop may not seek his own prestige in this service, his own personal advancement. Saint Augustine once related that he wept inwardly after his ordination to the priesthood, not only because he had lost the freedom of the philosopher, but also because he was beset by the realization: Now you bear not only your own burden; you must carry the others too. Now you must take responsibility not only for your own life, you will also be asked about the many who have been entrusted to you. Will I be able to bear up under that? Will I be able to serve them as they deserve? We find something similar in the history of all the great callings. A Moses, a Jeremiah, a Jonah struggle with all their powers against God's unreasonable demand that they be his mouth and his hand. They do not fear only, nor do they fear first, the contradiction of men, which they have amply experienced. They fear above all their own inadequacy. They see how far short, with their own human stature, they fall from what they should be. They fear that they will be unable to be credible when they take God's words on their poor human lips. Only apparently is Isaiah an exception. The glory of the thrice-holy God has appeared to him. But then he hears the voice of the Lord, who says: Whom shall I send? Who goes in my behalf? And he answers: "Here am I! Send me" (Is 6:8). He does not offer himself because he wants to achieve something for himself, but because God has need of him and because he knows that he is in good hands when he puts himself into God's hands.

With this confident awareness, Moses, Jeremiah, and the
many ambassadors of God throughout history could accept
their missions—credible, not through their own achievement
and greatness, but rather credible through the humility with
which they engaged themselves in service that they had not
sought for themselves. Credible because they moved their
own I to the side and gave God room.

And so we have come finally to the saint whom we have
recently commemorated in a year-long celebration, Wolf-
gang of Regensburg, who died one thousand years ago, in
994. Wolfgang did not seek the office of bishop. His way of
life appears over a long stretch of time as a painstaking search
for his true vocation. He studied at Reichenau and in
Würzburg, then became cathedral scholastic in Trier. Finally
Emperor Otto I called him to his chancellery in Cologne.
He declined the bishop's chair offered him by Bishop Bruno
of Cologne. He had not yet made up his mind, and he did
not want simply to enter the royal/ecclesial system that had
developed in the meantime. He wanted to find his way.
Wolfgang had turned forty years old before he came to his
own life decision. He became a monk, not in the splendid
monastery on Reichenau that he knew from his youth, but
in Einsiedeln, which he had chosen because of the strict
discipline of its rule. Thus a deeper and more struggling man
appears before us. We may conceive of the rule of Saint
Benedict, to which he now subordinated himself with his
whole heart, as a kind of inner portrait of this man. There it
says: "Having girt our loins with faith and the performance
of good works, let us walk his ways under the guidance of
the gospel, that we may be found worthy of seeing him who
has called us to his kingdom."

"Walk the ways of the Lord under the guidance of the
gospel"—Wolfgang had not yet arrived at the goal; the gospel

demanded more of him. Europe had become Christian, but this Christian Europe ended at the borders of Pannonia, today's Hungary. Christendom stood armed against the belligerent tribes of horsemen in the East. In the Battle at Lechfeld even Bishop Ulrich of Augsburg had fought in 955. He ordained Wolfgang priest in 968. But now a new hour was at hand. Wolfgang left as once the great missionaries from Ireland and England had left for the continent. He went to Hungary, not with a sword, but with the gospel, as the defenseless messenger of the defenseless Lord Jesus Christ.

His attempt at proselytizing failed, but his way with the gospel and for the gospel was still a way of divine guidance. Bishop Pilgrim of Passau summoned the no doubt suspicious "vagabond monk" to himself, but through the personal encounter he recognized in this man a true servant of Jesus Christ and recommended him to the emperor to be the bishop of Regensburg. Imperial advisors expressed extreme reservations against the poor and unknown monk, but Pilgrim's recommendation was accepted. So Wolfgang became bishop of the city on the Danube in 972/973.

Did he then succumb to career ambitions? His biographer Otloh of Saint Emmeram characterizes the transition to bishop's office with the words: *deserens monasterium, non monachum*—he left the monastic home but not the monastic life. He arrived at that place about which Isaiah spoke: Here am I, Lord, send me. Or at the place of Jonah, who—spewed forth from the whale—knew that he could now flee no longer but rather had to proclaim God's will. Now he could also do so, for he had indeed found his vocation. He was monk and priest, ready to walk the ways "that the Lord shows us".

Saint Wolfgang's years as bishop are characterized by two significant renunciations that are consistent with what we

have previously considered. Wolfgang gave his agreement to the establishment of the bishopric of Prague and thereby to the separation of Bohemia from his diocese. For bishops who thought more like princes and of the question of ownership, that might seem odd. But this holy bishop did not regard his mission from the viewpoint of power. His question was how the gospel and, via the gospel, men could best be served. The words that he pronounced in this moment show the figure of the Good Shepherd. "We see hidden in the earth of that land a precious pearl that we cannot acquire without sacrificing our treasures. Therefore, hear: Gladly I would offer up myself and what is mine so that the Church might be strengthened there and the house of the Lord acquire solid ground." Those are words that reach into the present and concern us. The renunciation of Bohemia so that a new diocese and vibrant Church might develop there out of the inner strengths of the country was able to become a strong bond between Regensburg and Prague, between Bavaria and Bohemia. For here we meet in exemplary fashion that frame of mind that creates freedom and establishes friendship. The ability to do without does not make one poorer. Rather the ability to do without is again and again the condition for true greatness, for greatness has to do with selflessness, with inner freedom, with purity of heart, and with recognition of the other, with justice and love. When we think of Saint Wolfgang, we seek these dispositions. Remembering him means opening ourselves to the other in the common search of the way of the Lord, not according to our notions, but "under the guidance of the gospel".

The other renunciation consisted in Wolfgang's implementing the separation of the offices of abbot and bishop. It may have been the case that it was difficult for him, who had found his vocation in becoming a monk, to relinquish the

abbot's staff of Saint Emmeram in order to be only Bishop of Regensburg. But Wolfgang saw very clearly the distinctive profile of each of the commissions. The monastic community needs its father entirely. He holds them together in their service of prayer and daily work so that they may really be a "school of service for the Lord", as Benedict formulated it. The bishop with his missionary charge must, however, always be able to go to the people. This decision, too, has left Wolfgang and his diocese richer. The bishop thereby became, not less, but more free for his mission. Thus Wolfgang's second important decision not only teaches us that renunciations are holy; we can also learn from this about the harmony between religious life and Christian service in the world.

A person's rank is probably best revealed in what he gives to other men, in how he is able to form other men. Wolfgang was influential, not through books, but rather through men, to whom he communicated his strength of faith and his humanity, which proceeded from his faith. It would take too long to enumerate all the benefits Regensburg received from Wolfgang's students. His favorite student, Tagino, became archbishop of Magdeburg; the episcopal sees of Trier, Merseburg, and Luettich were occupied by students of Saint Wolfgang. A series of abbeys sought their spiritual father in Saint Emmeram of Regensburg. Emperor Henry II, the saint, was educated by Wolfgang. In an especially nice coincidence, his student Gisela was to become the wife of King Stephen of Hungary, and thus the christianization of Hungary succeeded in a new generation, something for which Wolfgang had labored in vain.

"Blessed are they who fear the Lord and walk in his ways", the psalm tells us (cf. Ps 33:18). Every man wants to be happy. But how does he succeed? If we look at Wolfgang, the renunciations capture our attention first and above all. He declines

the office of bishop. He looks for the hiddenness of the monastery, its quiet and its peace. But he must leave and then even become bishop. He must at the same time renounce his own life and take the burden of another on himself because the Lord wants this of him. Has he thus missed happiness? Has he missed his own life?

The opposite is the case. He who would find himself loses himself. Whoever always looks at himself experiences what Lot's wife did: he becomes sour, turns into salt. Wolfgang's life decision was: Walk the way the Lord shows us under the guidance of the gospel. And so he entered into the promise of the psalm precisely because he did not look at himself. Because he gave much, because he gave *himself*, for this reason he was an interiorly rich and happy man—a man from whom a great inner light streamed and continues to stream. Wolfgang is a credible shepherd; more: a holy man. We may trust him. He shows the right path.

All Saints' Day

At the Feet of Saint Peter's Basilica

The "Campo Santo Teutonico", the German cemetery of Rome, once belonged to Nero's circus, which extended far into the Saint Peter's Square of today. This is the place where the first martyrs of Rome died for Christ. Nero made death into a spectacle. Some he had burned as living torches; others he had sewn into animal skins and thrown to wild dogs, who tore them to pieces. The cemetery where Peter was buried was nearby. One can now visit large parts of it under Saint Peter's Basilica today. The place where Nero played his macabre game of death has become a holy place for Christians. The tyrant took his own life, but even the presumably indestructible Roman Empire fell. The faith of martyrs, the faith of Peter, survived both the tyrants and the Roman Empire. It proved to be the force that in all downfalls was capable of building a new world.

Around the year 800 the Franks, at this point the supreme power of the West, founded a cemetery here in which they buried their pilgrims to Rome. The cemetery of the Germans in Rome evolved from this. It is not difficult to guess what the Franks were thinking to themselves. The tomb of Peter was no ordinary tomb. It bore witness to the stronger power of Jesus Christ, which extends beyond death. The

Pietà, middle panel of altar tryptych,
Saint Mary of the Pietà, Campo Santo Teutonico, Rome

sign of hope stands here over death. Whoever has himself buried in this spot holds fast to hope in the victorious faith of Peter and the martyrs. Peter's tomb, like every tomb, speaks of the unavoidability of death, but it speaks above all of the resurrection. It tells us that God is stronger than death and that whoever dies in Christ dies into life. One wanted to rest in the vicinity of Peter, in the vicinity of the martyrs, in order to be in good company in death and in the resurrection. One bound oneself to the saints and thereby bound oneself to the saving power of Jesus Christ himself. The communion of saints embraces life and death. One holds fast precisely in death in order not to fall into the void, in order to be pulled up by the saints into true life, in order at the same time in their company not to be alone before the judge, in order to be able to withstand, with them, the hour of judgment.

Thus the cemetery, the site of mourning and transience, has become a place of hope. Whoever has himself buried here thereby says: I believe you, Christ, who rose from the dead. I hold fast to you. I do not come alone in the mortal loneliness of those who cannot love. I come in the communion of saints, who even in death do not leave me. The transformation of the place of mourning into a place of hope is seen also in the external form of this cemetery and of any Christian cemetery for that matter. Flowers and more flowers decorate it; signs of love and bonds adorn it. It is like a garden, a small paradise of peace in a world without peace and thus is a sign of new life.

Cemetery as place of hope. That is Christian. That is the applied faith of the martyrs, applied faith in the resurrection. But we must add: hope does not simply cancel sadness. Faith is human, and it is honest. It gives us a new horizon, the larger and comforting view into the expanse of eternal life. But it

lets us at the same time remain in the place where we are. We do not have to suppress mourning; we accept it, and through the view into the expanse, mourning is slowly transformed and thereby purifies us, makes us more keen-sighted for today and tomorrow. It was very human that the funeral liturgy earlier omitted the alleluia and so gave clear room for mourning. We cannot simply jump over the Now of our lives. Only in accepting mourning can we learn to discover hope in darkness.

These connections are very poignantly expressed in the church to which this cemetery belongs. It is dedicated to the sorrowful Mother of God, who in Italian is called *Madonna della Pietà*, our Lady of Sympathy. Who could have held faster to the faith in the resurrection than Mary? Who could have been more certain of hope than she? But she suffers. Despite her certainty about the resurrection, death pains her; the moment of Good Friday is inexpressibly dark. She suffers as one who loves. She loves and suffers with us. Mary is depicted on the high altar of the church bending over the body of her son, who is carried by two men. Her face is full of sadness, but it is also full of kindness. The pain comes from the kindness and is therefore without bitterness or accusation. Let us take comfort in this picture. We learn from this picture that sadness, that pain accepted, makes us purer and more mature and helps us to see better the perspectives of life. It teaches us to turn more and more to the eternal. It helps us to be more loving and compassionate with those who bear suffering.

So the message of the cemetery is manifold. It reminds us of death and of eternal life. But it speaks to us, also, precisely of our present, everyday life. It encourages us to think of what passes and what abides. It invites us not to lose sight of standards and the goal. It is not what we have that counts but

rather what we *are for God* and *for man*. The cemetery invites us to live in such a way that we do not leave the communion of saints. It invites us to seek and to be in life what can live on in death and in eternity.

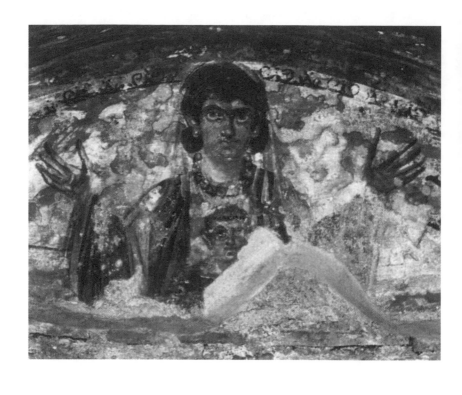

Fresco (Mother with Son) from the Cœmeterium Maius, Rome,
first half of the second century

All Souls' Day

Places of Hope—
The Roman Catacombs

On the street of tombs we have wandered into the land of the past. With these words Johann Jakob Bachofen, the great nineteenth-century researcher of fallen cultures, characterized the path of his science. From the very beginning, human beings have cared for their dead, trying to give them a kind of second life through their ministrations. Thus the past world of those who were once living remains in the world of the dead. Death has preserved what life was not able to preserve. How men lived, what they loved, what they feared, what they hoped for, and what they detested—nowhere do we learn these things so exactly as in the tombs that remain for us as a mirror of their world. And nowhere do we experience early Christianity so much in the present moment as in the catacombs. When we wander through their dark passageways, it is as if we ourselves have crossed the time line and are being watched by those who have preserved here their grief and their hope.

Why in fact is that so? There may be many reasons. The actual reason is no doubt that death concerns us today just as it did then. And if much from that time has become strange to us, death has remained the same. In the often rough inscriptions that parents have dedicated to their children, that

spouses have dedicated to each other, in the pain and confidence they express, we recognize again ourselves. Furthermore, faced with the dark question of death, we all seek some clue that allows us to hope, some direction, some consolation. Whoever walks the streets of the catacombs is not only drawn into the solidarity of all human mourning that is expressed there. He cannot at all take in the melancholy of the past by itself, so completely is that melancholy saturated with the certainty of salvation. This street of death is in reality a way of hope. Whoever walks it shares inevitably something of the hope that speaks here from all the images and all the words.

To be sure, we have not yet said much about our attitude toward death. Why in fact do we fear death? Why has mankind never been able to believe simply that nothing more comes after it? There are many reasons. First, we fear death simply because we are afraid of the void, afraid to step out into the completely unknown. We rebel against death because we simply cannot believe that so many great and meaningful things that occur in a life should suddenly fall into oblivion. We resist death because love demands eternity and because we cannot accept the destruction of love that death brings with it. We fear death because none of us can quite shake off the feeling that there will be a judgment in which the memory of all our failures emerges unvarnished that we otherwise are so busy finding a way to suppress. The question of judgment has left its mark on the funeral culture of every epoch. Love that surrounds the deceased should protect him. That so much gratitude accompanies him cannot be without effect at this judgment—so men thought and think.

We are rational today, at least we think we are. We want what is definite, not what is approximate. Hence we want to answer the question of death, not by means of faith, but with verifiable empirical data. A short time ago, reports of the

clinically dead became nice and eerie popular reading, which is again in the process of fading away. The calming effect they produce does not go far. It may be quite amusing to float over oneself for a few hours somewhere in the room and to look down, cheerful and touched, at one's own corpse and those left behind grieving. But one can certainly not occupy oneself in this way for an eternity. In the meantime, some pursue the empirical by reverting to the wholly archaic, seeking in spiritism, masquerading in more or less scientific forms, direct contact with the world beyond death. But even here the prospects are bleak. What one finds are but duplicates of life here. But what meaning would there actually be in having to exist again a second time without place or time? That is in reality the exact description of hell. A second, no longer temporary, duplicate of our life until then would in fact be damnation forever. Our earthly life has its temporal framework, and so we can get through it. We could not bear it for eternity. But what then? We do not want death, and life as we know it we do not want forever. Is man a contradiction in himself, a mistake of nature?

Let us keep these questions in our hearts as we walk along the paths of the catacombs. Only the one who can see hope in death can also lead a life of hope. What gave the possibility of such cheerful confidence to the men who have left behind here the symbols of their faith, which still speak to us today in the darkness of the subterranean passages? First, they were thoroughly clear on the fact that man taken for himself alone, completely limited to the empirically comprehensible, makes no sense. They were also certain that a mere prolongation of our present existence into the unlimited would be absurd. If isolation is deadly even in this earthly life and if only being-in-relation, love, sustains us, then eternal life only makes sense in a quite new totality of love that surpasses all temporality.

Since the Christians of that time knew this, they also realized that man is then understandable only if there is a God. If God exists—for them this "if" was no longer "if", and therein lies the answer. God had stepped out of his unknown distance and had entered their life in that he said: "I am the resurrection and the life" (Jn 11:25). And still other words illuminated the darkness of death: "I am the way, and the truth, and the life" (Jn 14:6). Jesus' words from his own Cross to the criminal crucified beside him: "Today you will be with me in paradise" (Lk 23:43) cast light into the fear of judgment. Above all: he had risen, and he had said: "In my father's house there are many rooms. . . . I go and prepare a place for you" (Jn 14:2). God was no longer a distant If. He really was. He had shown himself, and he was accessible.

Then everything else fell into place by itself. For if there is a God and if this God has wanted and wants man, then it is clear that his love can do what ours wants in vain, namely, to keep the loved one alive beyond death. Our cemeteries with their symbols of devotedness and fidelity are actually such attempts of love to hold tight somehow to the other, to give him yet another piece of life. And, indeed, he does continue still to live a little in us—not he himself, but something of him. God can hold on to more—not only thoughts, memories, aftereffects, but rather each as himself. In like manner the approaches of the old philosophy have their meaning for the Christian. This philosophy had said that, if you want to survive beyond death, you must acquire in yourself as much as possible of what is eternal: truth, justice, goodness. The more you have of these in yourself, the more of you remains, the more you remain. Or better: you must attach yourself to the eternal so that you belong to it, partake of its eternity. Hold fast to truth, and thereby belong to the One who is indestructible—that disposition now becomes quite real and

quite close: Hold fast to Christ; he carries you through the night of death that he himself has overcome. In this way immortality comes to make sense. It is no longer an endless duplication of the present but rather something entirely new and yet still *our* eternity: to be in the hands of God and thereby one with all the brothers and sisters he has created for us, to be one with creation—that is finally the true life, which we now can see only through the mist. Where there is no answer to the question of God, death remains a cruel puzzle, and every other answer leads into contradictions. If God exists, however, the God who has shown himself in Jesus Christ, then there is eternal life, and death is then also a way of hope.

It is this new experience that gives the catacombs their special character. So many of the images have crumbled or faded through the disadvantage of time. But they have lost nothing of the radiance over the centuries and, above all, nothing of the truth of hope that gave birth to them. There are the youths in the fiery furnace; Jonah, who is thrown back into the light from the belly of the whale; Daniel in the lions' den, and many others. The most beautiful is the Good Shepherd, whose direction we can trust without fear because he knows the way through the dark valley of death. "The Lord is my shepherd. Nothing shall I lack. . . . If I must walk in middle of the shadow of death, I fear no evil, for you are near me" (Ps 22:1, 4; LXX).

Sources of Texts

"Ochs und Esel an der Krippe" (Ox and Ass at the Crib): In J. Ratzinger, *Licht, das uns leuchtet* (Freiburg, Basel, Vienna: Herder, 1978), pp. 25–37; here in an expanded version.

"Die Weihnachtsbotschaft in der Basilika Santa Maria Maggiore zu Rom" (The Message of the Basilica of Saint Mary Major in Rome): In M. Schneider and W. Berschin, eds., *Ab oriente ed occidente: Kirche aus Ost und West: Gedenkschrift für W. Nyssen* (St. Ottilien: EOS, 1996), pp. 361–66.

"'Vorsitz in der Liebe': Der Cathedra-Altar vom St. Peter zu Rom" ("Primacy in Love": The Chair Altar of Saint Peter's in Rome): In E. Kleindienst and G. Schmuttermayr, eds., *Kirche im Kommen: Festschrift für Bischof J. Stimpfle* (Berlin: Propylaeen, 1991), pp. 423–29.

"'Die Botschaft hör ich wohl . . .'" ("I Do Indeed Hear the Message"): Until now printed only in journals.

"Das Lachen Saras" (Sarah's Laughter): Under the title "Das Lamm erlöste die Schafe: Betrachtungen zur österlichen Symbolik", in J. Ratzinger, *Schauen auf den Durchbohrten: Versuch einer spirituellen Christologie*, 2nd ed. (Einsiedeln: Johannes-Verlag, 1990), pp. 93–101 (English trans.: *Behold the Pierced One*, trans. Graham Harrison [San Francisco: Ignatius Press, 1986], pp. 111–21).

"Der Heilige Geist und die Kirche" (The Holy Spirit and the Church): In A. Coreth and I. Fux, *Servitium pietatis: Festschrift für Kardinal Groer zum 70. Geburtstag* (Salterrae Maria Roggendorf, 1989), pp. 91–97.

All others: Not until now published in printed form.